"Color Theory is mandatory (not optional) training for professional makeup artists. We live and work in an HD (high-definition) world. Our work in print, video, and film is scrutinized under a lens that sees up to 6x closer than the human eye and can be presented in full HD, formatted up to 5,000 sq ft (IMAX). In this environment, complexions MUST be matched exactly (skin depth and undertone), and all other color makeup choices must be compliant with the technology. That level of precision can only be accomplished when you've mastered the science of color theory. There is no excuse for bypassing this training if you're an artist planning to build a successful professional career in the 21st Century."

-Kevin James Bennett, 2x Emmy Award-winning make-up artist and educator

COLOR THEORY FOR THE MAKE-UP ARTIST

Color Theory for the Make-Up Artist: Understanding Color and Light for Beauty and Special Effects analyzes and explains traditional color theory for fine artists and applies it to the make-up artist.

This book is suitable for both professionals and beginners who wish to train their eye further to understand and recognize distinctions in color.

It explains why we see color, how to categorize and identify color, relationships between colors, and it relates these concepts to beauty and special effects make-up. The book teaches the reader how to mix flesh tones by using only primary colors, and explains how these colors in paints and make-up are sourced and created. It also discusses the reason for variations in skin colors and undertones, and how to identify and match these using make-up, while choosing flattering colors for the eyes, lips, and cheeks. Colors found inside the body are explained for special effects make-up, like why we bruise, bleed, or appear sick. Ideas and techniques are also described for painting prosthetics, in addition to using color as inspiration in make-up designs. The book also discusses how lighting affects color on film, television, theater, and photography sets, and how to properly light a workspace for successful applications.

Katie Middleton is a professional make-up artist for film and television with a background in fine art, specializing in portrait and representational painting. She earned her Bachelor Degree in Fine Art from Pratt Institute in Brooklyn, New York, where she was honored with the Early Career Achievement Award in 2016. Some of her make-up credits include the film *Loving*, where she was nominated for a Make-Up Artists and Hair Stylists Guild Award in 2017; Showtime's *Homeland*; AMC's *Turn: Washington's Spies*; PBS's *Mercy Street*; and *Mystery Science Theater 3000*. Katie also studied make-up and special effects at Vancouver Film School where she received the Make-Up Achievement Award.

2017003125

COLOR THEORY FOR THE MAKE-UP ARTIST

Understanding Color and Light for Beauty and Special Effects

by Katie Middleton

Routledge
Taylor & Francis Group

LONDON AND NEW YORK

First published 2018
by Routledge
2 Park Square, Milton Park, Abingdon, Oxon OX14 4RN
52 Vanderbilt Avenue, New York, NY 10017

Routledge is an imprint of the Taylor & Francis Group, an informa business

Library of Congress Cataloging-in-Publication Data
A catalog record for this book has been requested

ISBN 13: 978-1-138-09524-3 (hbk)
ISBN 13: 978-1-138-09525-0 (pbk)

Typeset in Gillsans and Helvetica
by Apex CoVantage, LLC

For Mom

CONTENTS

ACKNOWLEDGMENTS

I'd like to give a very special thank you to everyone who helped make this book possible.

Thank you to my editors **Stacey Walker** and **Katie Finn** at Focal Press/Routledge for publishing this book and for all of your guidance throughout the process.

Thank you **Stan Edmonds, Vivian Baker, Ashley Hooker, Ashley Fetterman, Rhonda Bareford, Kevin James Bennett, Kate Griffiths**, and **Kholi Hicks** for your input and helpful feedback.

Thank you **Iona Fromboluti** for your memorable Light Color and Design class at Pratt Institute.

Thank you to my mom, **Diana Scott Welton**, for your never-ending encouragement and for all of the time you spent reading and re-reading every draft of this book.

Thank you to my husband, **Joe Ahern**, for always inspiring me and supporting my career, ideas, and dreams.

THANK YOU:

Harris Middleton
Dad and Danna Middleton
Caroline Wolff
Jan Wolff
Kenny and Karen Myers
Christian Kehoe
Terri Tomlinson
Mary Costa
David Maiden
Mas Submaranian
Andrea Shea
Daniel Henshall
Rachel Nicole
Tricia Pain
Elizabeth Paschall
Channing McKindra
Jason Waggoner

Hollie Christian-Brookes
Routledge/Focal Press
The Metropolitan Museum of Art
Make Up For Ever
RCMA
Anastasia Beverly Hills
Skin Illustrator
Fleet Street
The Makeup Light
MAC Cosmetics
Graftobian
Ben Nye
Popular Science Magazine
Star Waggons
Vancouver Film School
Pratt Institute
Shutterstock

We live in a colorful world with a seemingly infinite spectrum around us at all times. We associate certain colors with specific moods or feelings. We have favorite colors that we like to wear or have in our environment around us. And so our perception of color becomes very subjective in our lives.

Color creates a visual and psychological meaning of its own. This is exactly why the make-up professional requires a solid understanding of color, not only in its relationship to what "appears" flattering, but also how it can be used "correctly". Color and light have absolute laws that govern how they are perceived. And although, at first, this may seem to take the "fun" out of playing with color, this knowledge will actually expand your pleasure and provide you, as an artist, with a strong tool.

When I began my career as a make-up artist in the '80s, I lacked a proper understanding of color. Like most make-up artists, even today, I simply used my own visual intuition to guide me. How much faster I would have developed and improved the quality of my work if I had a systematic understanding of color and light. This book provides that for the make-up artist!

In life, we have complete control over how we use color in our make-up and clothing. As a make-up artist working in any visual medium, we must coordinate the colors we use based upon the overall design (and intent) of the production, along with the art department and wardrobe. However, all of the work that we do is subject to a number of other factors; the type of lighting that illuminates our make-up, how it is captured by a camera system with whatever filters are used, and finally color graded (corrected and or altered) for the purposes of dramatic stylization in post-production by a professional colorist. This is not even to mention how the final work will appear completely different on various devices like televisions, computers, or phones, due to their various color gamuts and profiles.

Sound complicated? It isn't really, when you understand that your only focus is on the very first part of this process; the colors of the make-up as seen in the light by your eyes.

The vast majority of professional make up artists do not have an education in fine art. This is why Katie is the ideal person for this book, with her background in art, make-up, and practical work experience in film and television. Katie has created an invaluable item: an addition for every make-up artist's library and even in the kit! Unlike other books about color theory, Katie has made it clear and practical for the make-up artist to use. The application of these principles will result in strong improvements in your work.

Be prepared to be invigorated and empowered as you will see how you can use colors in a whole new way!

Stan Edmonds
Department Head of Make-Up Design for Film and Television
at Vancouver Film School(IATSE 891)

INTRODUCTION

There is a reason color theory is a fundamental topic when studying any form of fine art. It is a necessary foundation skill for understanding how to manipulate color properly and creatively, and it is taught widely in countless types of visual courses including painting, graphic arts, film, theater, interior design, and fashion; so, why is there not a heavy focus on it in make-up artistry, as well?

As make-up artists, we control color the same way a painter does. We choose color palettes, match colors, blend new colors, and create designs on a canvas that is always changing. Some colors cancel others, some balance each other, and some oppose other colors. However, painters seldom have to consider inconsistencies in how their art will be lit and where it will be displayed the way that a make-up artist does. This makes it essential that a make-up artist not only understands colored materials, but also colored lighting. Color is nonexistent without light, and lighting is crucial in theater, television, film, and photography. Recognizing these properties and relationships is the first step in understanding color theory. The more you familiarize yourself with color, the easier it will be to use it effectively and effortlessly.

This book will teach you the principals of color theory, and show you how to apply them directly toward make-up applications. You will learn how to mix any color using just red, yellow, blue, and white, and you will learn how lighting affects these mixtures.

I recommend you read this book in order and in its entirety, even if you're only interested in specific sections. The lessons in color correcting, foundation matching, and simultaneous contrast from Chapter 4 on beauty make-up can also be helpful in special effects applications. The explanations found in Chapter 5 on special effects make-up regarding why our skin blushes, bruises, and changes may be helpful to a beauty make-up artist. The fundamentals of color theory, pigments, and light are important for any artist. Once you have learned how to identify colors by their hue, value, and intensity in Chapter 1, each following chapter should be easier to understand.

Color theory is not a simple topic. I recommend you take the time to practice matching and mixing make-up or paints, and even sign up for art classes and further explore color on your own. The best way to truly understand color is to use it and experiment with it.

Whether you are a professional or a beginner, you will never stop learning. There will always be new products, techniques, fashions, and information, so keep practicing and creating.

Personally, I feel that studying art and color prior to becoming a make-up artist gave me an advantage and an invaluable skill. I hope this book will help do the same for you.

Katie

1

COLOR THEORY

WHY WE SEE COLOR

It's easy to take color for granted, because today we have access to any color imaginable. We can quickly select and mix millions of color combinations using paint, dye, or even digital color on a screen. Even though we are equipped with color vision without having to think about it, it's important to take time to understand color, because it's one of the most important tools we have as artists.

The Visible Spectrum

All colours will agree in the dark.

—Francis Bacon (1561–1626)

In the late 1600s, Sir Isaac Newton discovered that white light could be broken down into all

FIGURE 1-2 PRISM SEPARATING LIGHT. Original image by Ktsdesign/©Shutterstock.com. Edited by author.

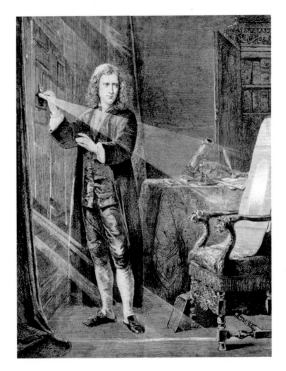

FIGURE 1-1 SIR ISAAC NEWTON (1642–1727) EXAMINING LIGHT WITH A PRISM. Everett Historical/©Shutterstock.com.

of the colors of the rainbow, which make up the **visible spectrum** that we know today. Through his experiments of passing white light though a prism, he found that the light refracts and separates into red, orange, yellow, green, blue, indigo, and violet. This made it apparent that white is not a separate color of light, but instead is the result of all color frequencies being reflected at one time. The existence of light is the reason we are able to see color at all, which explains why everything appears black when the lights are turned off.

The spectrum that we see is a type of electromagnetic radiation, and each colored wavelength has its own frequency. The human eye is sensitive to these wavelengths and the brain is able to identify them as colors. Red has the longest wavelength and the shortest frequency, while violet has the shortest wavelength and highest frequency. Some animals and insects (like bees) can see beyond the human's visible spectrum and can observe other frequencies, like ultraviolet light.

Every object that we see has its own molecular structure, which absorbs or reflects the wavelengths that we perceive as colors. Objects that appear brightly colored **reflect** more light waves, while those that appear dark **absorb** more light waves. These colored light waves are projected into our retinas and processed by our brains. For example, a green object will absorb all colors of light except green, which it reflects back to our eyes and allows us to identify it as green. When an object absorbs all light waves at once, it appears black. When an object reflects every light wave, we see white. Grey reflects all colors partially but equally, which results in the lack of a pronounced color. The various combinations of these wavelengths and light make it possible for the average human to see around 10 million colors.

> *White may be said to represent light, without which no color can be seen.*
> —Leonardo da Vinci (1452–1519)

CLASSIFYING COLOR

The Color Wheel

Throughout history, the **color wheel** has gone through many transformations. Before the wheel was created, colors had previously been arranged in a linear way, which made it more difficult to understand their relationships with each other. Today, the most common version is a diagram where the colors are arranged in a circle in order of the visible spectrum. This makes it easy to reference and observe harmonious colors as well as their opposites. (Notice, we use the term "Purple" when referring to the color wheel because "Violet" is actually the name of the spectral color of light. "Indigo" is also the name of the spectral color, but is referred to as "Blue-Purple" on the color wheel.)

French painter **Eugène Delacroix** found it invaluable to keep a color wheel nearby while he painted portraits and murals back in the 1800s. This is still a very relevant practice today, and you should consider keeping a color wheel handy while learning to master color for make-up applications.

A **WHITE** object reflects all lightwaves

A **GREEN** object reflects green lightwaves back to our eyes and absorbs all other lightwaves

A **BLACK** object absorbs all lightwaves

FIGURE 1-3

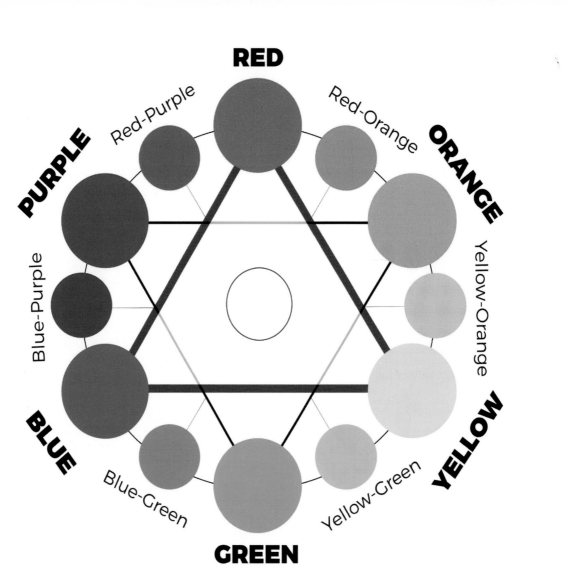

FIGURE 1-4 COLOR WHEEL

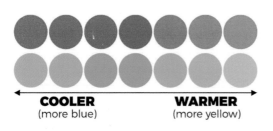

FIGURE 1-5

Warm and Cool Colors

Color temperature classifications are based off physical and psychological effects and appear relative to their names. **Warm colors** are typically red, orange, and yellow, and are reminiscent of fire and warmth. **Cool colors** are typically blue, green, and purple, and are reminiscent of ice and coldness.

WARM Colors

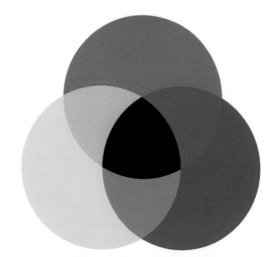

COOL Colors

FIGURE 1-6

There are exceptions to this: for example, when a green is more yellow-green, it can be considered warm, and when a purple contains much more red in it than blue, it can also be considered warm. This is discussed more in Chapter 3, because identifying color temperature is a very helpful tool in selecting the right make-up for different **undertones**.

Primary Colors

Most artists are familiar with the three traditional **primary colors**, which are **red, yellow**, and **blue**.

FIGURE 1-7

These are the base colors in mixing colored pigments because they cannot be created by

intermixing any other colored pigments. For example, a pure red has no blue or yellow present, a pure yellow has no red or blue present, and a pure blue has no red or yellow present. In theory, you can take these three colors (plus white), and create over 100 million different colors including black (by equally mixing red, yellow, and blue).

RED-YELLOW-BLUE
Primary Colors of Pigments

FIGURE 1-8

However, we cannot achieve a perfect black by mixing primary paint colors due to limitations in pigments available.

This method of color mixing is known as the **RYB system** (Red-Yellow-Blue).

The Red-Yellow-Blue is the most relevant system for make-up artists because we work with pigments the same way a painter does. Later in this chapter, we will discuss two other systems that involve different primary colors (CMY and RGB).

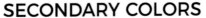

SECONDARY COLORS

FIGURE 1-9

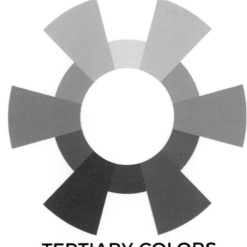

TERTIARY COLORS

FIGURE 1-10

Secondary Colors

Secondary colors are the direct mixture of two primary colors. For example, red + yellow = orange, yellow + blue = green, and red + blue = purple. Therefore, **orange**, **green**, and **purple** are secondary colors (when mixing colors using pigments such as paint or make-up in the RYB system).

Tertiary Colors

Tertiary colors are the result of mixing a secondary color with a primary color. There are six of these, and they are blue-purple, blue-green, yellow-green, yellow-orange, red-orange, and red-purple.

In between each pair of colors on the color wheel, you'll find the result of their mixtures. Note that the three **primary** colors create a **triad** (a triangular shape on the color wheel), and the **secondary** colors also create a triad. **Tertiary** mixtures are found in between each secondary.

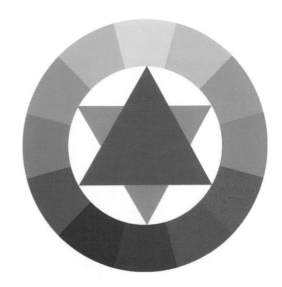
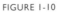

FIGURE 1-11

COLOR RELATIONSHIPS

Complementary Colors

Select a color on the color wheel, and look at which color is directly across from it. These pairs

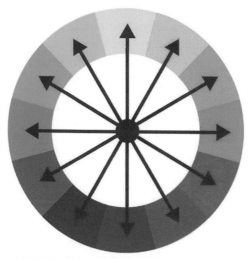

COMPLEMENTARY COLORS

FIGURE 1-12

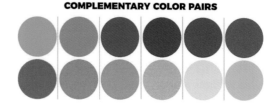

WHEN USING COMPLEMENTARY
COLORS IN DESIGN, THEY CAN BE
PLACED NEXT TO EACH OTHER
FOR CONTRAST BECAUSE THEY ARE
OPPOSITES.

9

are considered **opposites**, which are also known as **complementary colors**. For example, red and green are complements, blue and orange are complements, and yellow and purple are, too.

When combining two complementary colors with paint or make-up, they will dull and neutralize each other. This is because combining two complements is the same as mixing all three primary colors. For example, blue and its complement orange (made up of red and yellow) account for all three primary colors. This is why we use the term **complement**, because it is defined as *a thing*

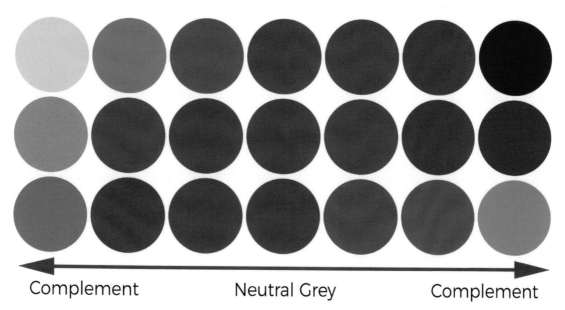

Complement Neutral Grey Complement

FIGURE 1-13

that completes or brings to perfection, meaning these complementary colors come together to complete the **primary triad**.

Mixing equal parts of two complements results in black. (Black is also the result of mixing the three primary colors equally.) Equal amounts of complementary colors, plus white, result in a shade of **neutral grey**. Neutral grey is also known as a **complementary grey**, and has no apparent color cast. Again, this only works when mixing pure primary and secondary colors, and limitations in available paint and make-up pigments give us different results.

Mixing complements is a great way to neutralize a hue without using black. For example, if you have an orange that is too bright, adding a little of its complement (blue) will dull the orange. Adding black will also dull any color, but keep in mind black is a

combination of all three primary colors, so adding it may also deaden the color mixture by adding other unwanted colors. It is much more effective to control your colors by neutralizing them with their complements.

In fine art, as well as in make-up, it is very important to understand complementary colors and be confident about the ways to use them.

Analogous Colors
Analogous colors are groups of colors that are next to each other on the color wheel. They are harmonious.

Triadic Colors
Triadic colors are those that are spaced evenly on the color wheel and form a triangle.

ANALOGOUS

FIGURE 1-14

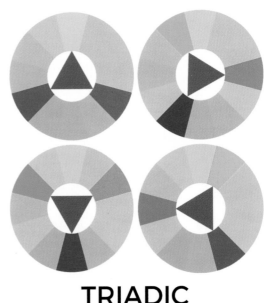

TRIADIC

FIGURE 1-15

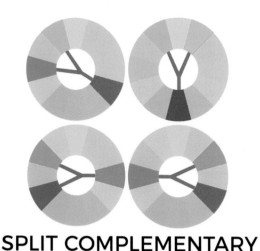

SPLIT COMPLEMENTARY

FIGURE 1-16

Split-Complementary Colors

A **split-complementary** color scheme is a three-hue variation of a complementary color scheme. Take one side of two complements and split it using the two surrounding colors. The color and its opposing split-complementary pair will be the three colors that make up this scheme.

Tetradic Colors

Tetradic colors are also referred to as **double complementary colors**. They form a rectangle on the color wheel and consist of two pairs of complements.

Square Color Scheme

A **square color scheme** consists of four colors that create a square on the color wheel. It is similar to the tetradic color scheme, except all colors are spaced evenly.

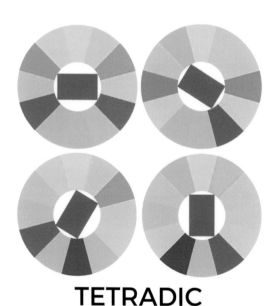

TETRADIC

FIGURE 1-17

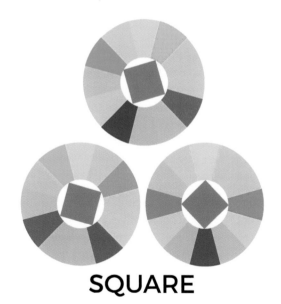

SQUARE

FIGURE 1-18

THE THREE ATTRIBUTES OF COLOR

In order to properly categorize colors, they can be broken down into three attributes: **hue**, **value**, and **intensity**. This vocabulary helps artists identify and create a language for the subtle changes and relationships of color.

HUE

FIGURE 1-19

Hue

The first attribute of a color that you should define is its **hue**, which refers to its **base** or **pure color** and is labeled by its common familiar name. Pink and burgundy are both considered red in hue, but are very different colors. That's because their other two attributes of value and intensity vary.

Identifying the hue may sound simple, but what color would you consider brown? Look closely, and you'll see that every brown can be described by a hue like red, yellow, orange, or red-purple. Browns are dull and typically dark, which sometimes makes them difficult to identify. You can categorize any color using a primary, secondary, or tertiary hue unless it is a neutral

grey, black, or white. Notice in the chart how each type of brown is actually classified as a specific hue.

FIGURE 1-20

Value

The second color attribute is **value**. Value is a measurement that describes how light or dark a hue is, and can also be referred to as **brightness** or **luminosity**. Take a look at the **value scale** (also known as a **grey scale**).

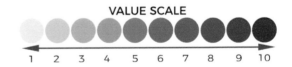

FIGURE 1-21

The scale pictured has ten steps in value, but it can have less or many more or depending on its purpose. Determining a color's value can be easier when comparing it to the steps on a value scale.

How does each hue on the color wheel relate to a value on the value scale?

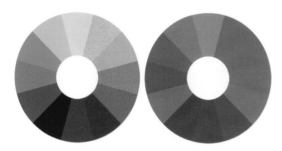

FIGURE 1-22

Imagine taking a color photograph and converting it to black and white. Even though we can't identify the colors when they're in greyscale, we are still able to understand the image and lighting based on the range of values. In the following example, you can see that the stripes on the boy's shirt have different hues but almost identical values, which makes them difficult to differentiate when the photo is converted to black and white.

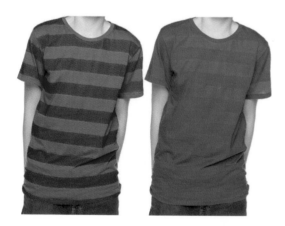

FIGURE 1-23 THE RED STRIPES ARE THE SAME VALUE AS THE BLUE STRIPES. Original Image by SergiyN/©Shutterstock.com. Edited by author.

A common mistake would be to assume that blue is always darker than yellow. This isn't always true because it actually varies, depending on the object's value. For example, blueberries are darker in value than bananas, while a yellow bird can have a darker value than the blue sky.

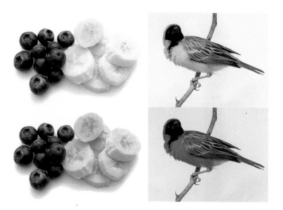

FIGURE 1-24 Original Images by Quang Ho, FRDMR/©Shutterstock.com. Edited by author.

It's easier to see that all colors can share the same ranges in value when comparing them to a value scale on the following chart (figure 1.25).

Intensity

The third and final attribute of a color is **intensity**. Intensity is the strength or weakness of a hue. It can also be referred to as **chroma, saturation**, or **purity**.

For example, two people can be wearing red shirts that are the same value, but one is new and the other is faded. The new shirt is not necessarily darker in value, but instead it is more saturated with an intense red (Figure 1.26).

You can also think about starting with a bright red paint and slowly mixing a grey paint into it.

VALUE

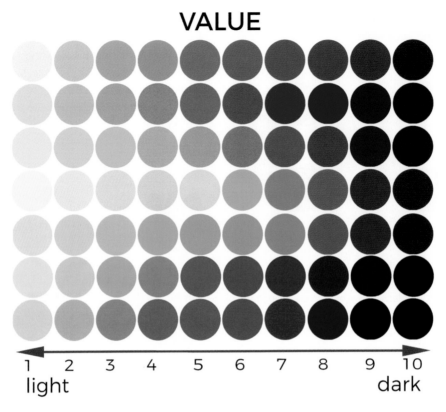

1 2 3 4 5 6 7 8 9 10
light **dark**

FIGURE 1-25

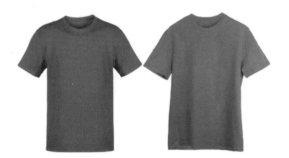

FIGURE 1-26 BOTH SHIRTS ARE SIMILAR IN VALUE, BUT THE LEFT SHIRT IS INTENSE AND THE RIGHT SHIRT IS DULL. Original Images by Neamov, Dmitry Zimin/©Shutterstock.com. Edited by author.

The red you started with will fade in intensity as the grey is added. Mixing two colors of paint always results in a loss of intensity.

Many times a color is considered to be grey once it becomes very low in intensity. However, a color is not a true **neutral grey** unless it is completely absent in all color. If you have ever painted a wall in a house using what you thought to be a "neutral" paint, you may have discovered that it actually appeared a color like purple or pink when the daylight changed. This is because the color was not completely neutral, but was instead, a very low-saturated hue. Look carefully when dealing with grey to see if it has a warm or cool color cast, and identify its hue the same way you would when classifying a brown or any other color.

INTENSITY

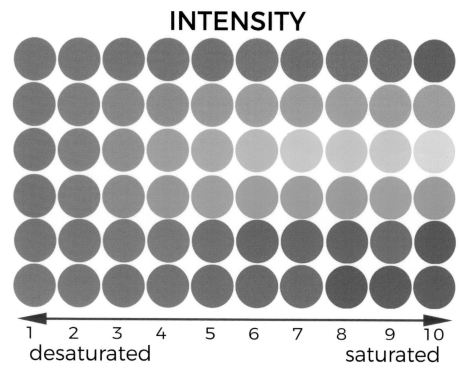

1 2 3 4 5 6 7 8 9 10
desaturated saturated

FIGURE 1-27

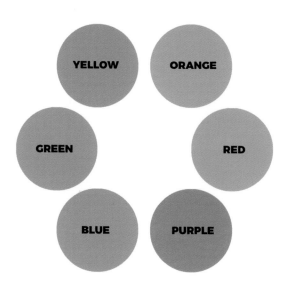

YELLOW ORANGE

GREEN RED

BLUE PURPLE

FIGURE 1-28

Munsell Color System

Albert Henry Munsell was an artist from the early 1900s who classified colors by their three attributes on a numerical scale. Using his color tree system, the color dimensions of hue, value, and intensity were arranged visually on one chart. By creating this system, he made it easier for artists to discuss color in a universal language.

> *The terms used for a single hue, such as pea green, sea green, olive green, grass green, sage green, evergreen, invisible green, are not to be trusted in ordering a piece of cloth. They invite mistakes and disappointment. Not only are they inaccurate: they are inappropriate. Can we imagine musical tones called lark, canary, cockatoo, crow, cat, dog, or mouse, because they bear some distant resemblance to the cries of those animals?*
> —Albert Henry Munsell (*A Color Notation*, 1905)

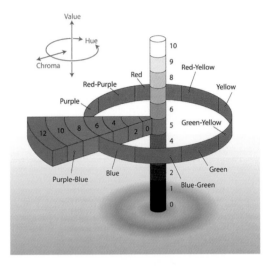

FIGURE 1-29 LOVEgraphic/©Shutterstock.com.

Munsell also discovered that when a hue reaches its **peak chroma value**, it varies from color to color. For instance, yellow is most intense at a lighter value, and blue is the most intense when its value is dark. Every color has a different peak chroma value.

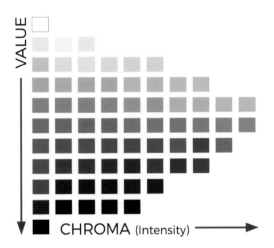

FIGURE 1.30

Categorizing Color

Let's use the color **beige** as an example. While "beige" may be the name of a paint or fabric color, it can have different variations and meanings to different people. Both color examples *Beige A* and *Beige B* (featured on page 17) can be referred to as "beige" or "nude" and countless other common names, so we need to describe them by their hue, value, and intensity to identify them consistently.

First, classify *Beige A* by its **hue**. If you look at it carefully, you'll see it's closer to yellow than any other color on the color wheel. When you look at *Beige B*, you'll see it appears red-purple. You can describe every color using a **primary**, **secondary**, or **tertiary** hue (unless it is colorless like black, white, or neutral grey).

Next, you'll need to determine the color's **value**. You can see on the value scale that *Beige B* is slightly darker than *Beige A*. On a scale from 1–10 (light to dark), *Beige A* is about a 1, and *Beige B* is about a 2. Both are considered to be light in value.

Last, to determine a color's **intensity**, consider how bright or dull it is. You can also give this a numeric value based on a scale. Keep in mind that the most intense a color can be is its purest color. Also, be aware that light colors are not always intense, and dark colors are not always dull. For example, a dark royal blue has a high intensity, while a pastel yellow is very low in intensity. On an intensity scale from 1–10 (intense to dull), both *Beige A* and *Beige B* are very dull and approximately a 10.

Beige A:

Hue: Yellow **Value:** 1-Light
Intensity: 10-Dull

Beige B:

Hue: Red-Purple **Value:** 2-Light
Intensity: 10-Dull

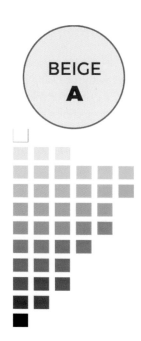

FIGURE 1-31

FIGURE 1-32

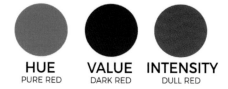

HUE	VALUE	INTENSITY
PURE RED	DARK RED	DULL RED

FIGURE 1-33

By referencing these colors on a chart like the Munsell Color Chart, it's easier to determine where they rank on hue, value, and intensity. Here are a few more examples of colors that have been categorized (from 1–10 on a value and intensity scale; light to dark and intense to dull).

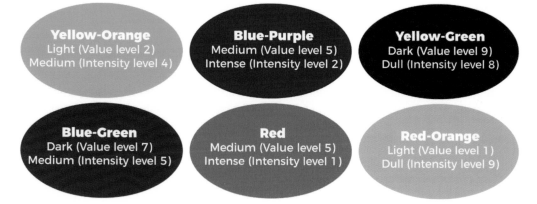

Yellow-Orange
Light (Value level 2)
Medium (Intensity level 4)

Blue-Purple
Medium (Value level 5)
Intense (Intensity level 2)

Yellow-Green
Dark (Value level 9)
Dull (Intensity level 8)

Blue-Green
Dark (Value level 7)
Medium (Intensity level 5)

Red
Medium (Value level 5)
Intense (Intensity level 1)

Red-Orange
Light (Value level 1)
Dull (Intensity level 9)

FIGURE 1-34

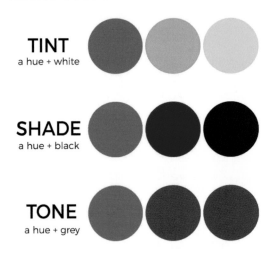

TINT
a hue + white

SHADE
a hue + black

TONE
a hue + grey

FIGURE 1-35

Tints

When you add white to a color it is called a **tint**. Adding white will make your hue lighter on the value scale.

Shades and Tones

Adding black to darken any hue is called a **shade**. Adding grey is called a **tone**. When mixing a tone, you can add black and white together to make grey. You can also create a **neutral grey** by mixing two complementary colors equally and adding white.

Monochromatic Colors

If a painting is **monochromatic**, it means it only has one hue in different tints, shades, and tones. The word comes from *mono* (meaning one) and *chromatic* (meaning it is relative to color).

Achromatic Colors

Achromatic is defined as being "without color". If a painting is considered achromatic,

then only a palette of black, white, and neutral grey is used.

Darkening Hues without Using Black

Adding black may darken your color quickly, but it is not necessarily the best choice if you want to keep the color from becoming too grey or dull. Black is an **achromatic** color, which means it is a color without a hue. Neutral grey is a tint of black, so it also has no hue and is achromatic. While adding black (or dark grey) successfully darkens the value, it also can dull the color more than you might expect.

If you want to darken a color without quickly greying it, try adding an intense color with a dark value (like a rich red-purple or blue) instead of using black. If the result needs to be more subdued, try adding the color's complement or a mixed brown. This helps when replicating colors found in nature, since a pure black is rarely found. It also gives you better control over manipulating a color because you're only adding one hue at a time.

> SOME ARTISTS, INCLUDING MANY OF THE ORIGINAL IMPRESSIONISTIC PAINTERS, BANNED BLACK COMPLETELY FROM THEIR PALETTES BECAUSE THEY FELT THEY COULD CREATE RICHER COLORS WITHOUT IT.

Lightening Hues without Adding White

If you are painting a subject, it's easy to only focus on its value the same way you would as if you were drawing in pencil. For example, if you were painting an apple, you could simply say that it's red. You could then paint it in terms of value by just adding white to the red for highlights and black for the shadows. This painting would appear monochromatic. If you forced yourself to look more closely at the apple, you would notice that the highlights are not just lighter in value, but most

likely different hues, and intensities, too. You may notice sections of intense colors like yellow or red-orange. Sometimes painting with a pure color that is high in intensity actually appears brighter than a pure white would. Study the shadows the same way, and you'll notice that they are also made up of colors like deeper blues or purples.

> IF YOU'RE HAVING A DIFFICULT TIME
> IDENTIFYING A COLOR, TAKE A WHITE
> PIECE OF PAPER AND PUNCH A SMALL
> PINHOLE THROUGH IT. USE THIS AS A
> VIEWFINDER TO ISOLATE THE COLOR,
> AND IT SHOULD BE EASIER TO ANALYZE.

Take a look at Vincent van Gogh's painting "Shoes". The painting is of a brown pair of shoes on a brown floor. Instead of choosing a brown paint and highlighting it with white and darkening it with black, he chose to study the colors closely instead.

You will see yellow browns, orange browns, red browns, and cool browns. Some of the highlights are made from bright yellows and oranges, and the shadows are made of blues, greens, and burgundies.

Had Vincent van Gogh decided to use a single brown color for the shoes and floor, his painting would have looked like this digitally edited monochromatic version. You can see that when the different hues of brown are removed, the result is a boring and dull painting.

> It often seems to me that night is still more richly
> coloured than the day; having hues of the most intense
> violets, blues and greens. If you only pay attention to it
> you will see that certain stars are lemon-yellow, others
> pink or a green, blue and forget-me-not brilliance. And
> without my expatiating on this theme it is obvious
> that putting little white dots on the blue-black is not
> enough to paint a starry sky.
> —Vincent van Gogh (1853–1890)

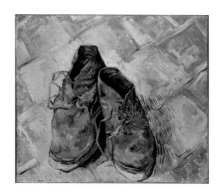

FIGURE 1-36 "SHOES" BY VINCENT VAN GOGH (1888) OIL ON CANVAS. The Metropolitan Museum of Art, New York.

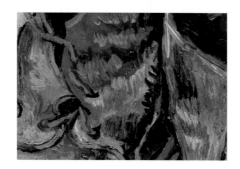

FIGURE 1-37 DETAIL OF "SHOES" BY VINCENT VAN GOGH (1888) OIL ON CANVAS. The Metropolitan Museum of Art, New York.

FIGURE 1-38 A DIGITALLY EDITED MONOCHROMATIC VERSION OF "SHOES" BY VINCENT VAN GOGH. The Metropolitan Museum of Art, New York.

Color Constancy

Color constancy describes a phenomenon where we perceive and categorize a color even though colored lighting may make it seem like a different hue. For example, we know that a banana is yellow even if it is observed under a red light, which makes it appear orange. Our brains determine that it is yellow, based on familiarity, which can lead us to make quick assumptions, and consequently neglect to analyze true colors. Color constancy maximizes our brains' efficiency by preventing us from making new decisions every time we see an object. Therefore, it is important to train yourself to become more sensitive when observing actual color instead of relying on a common preconception. Pay close attention to how light and an environment affect an object's color.

> **The mind stands in the way of the eye.** *That's why most beginning painters don't paint what the eye sees, but what the mind **lets** the eye see. They paint what they **expect** to see.*
> —Arthur Stern from "How to See Color and Paint It" (1984)

If you were to paint a white object like an egg on a white background, it's easy to assume that you would predominantly use white and simply add grey shadows.

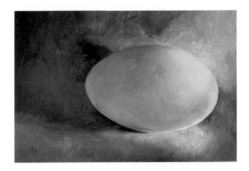

FIGURE 1-40 Painting by the author.

> *Shadow is a color as light is, but less brilliant; light and shadow are only the relation of two tones.*
> —Paul Cezanne (1839–1906)

In the following portrait, you can see that half of the face appears green due to the light that is filtered through the green visor. Even though bright green paint is used for the color of the skin, we would never assume that the person's skin is actually green. **Color constancy** allows our brains to disregard the added colored lighting and quickly recognize that the face is a flesh tone.

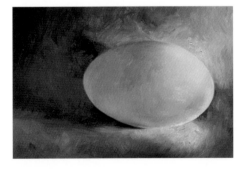

FIGURE 1-39 Painting by the author.

Don't be complacent by letting your brain tell you that the egg is just white. Instead, look at it closely and find all of the color variations. White objects reflect colors that surround them, so most likely you would be painting with very little pure white (if any).

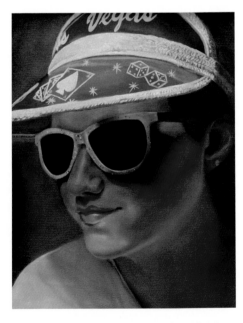

FIGURE 1-41 "CAROLINE" OIL ON CANVAS. Painting by the author.

20

COLOR SYSTEMS

RYB Color System

The **RYB Color System** is made up of the primary colors **red**, **yellow**, and **blue**.

The secondary colors in this system are orange, green, and purple. This is the main color system discussed in this book because it is the most relevant to fine artists and make-up artists, as it relates to the practice of mixing pigments like those found in paint or cosmetics. However, this is not the only system used for color mixing. There are two other systems (known as RGB and CMY) that deal with printing and scientific light.

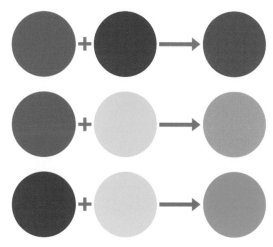

MIXING **R-Y-B** SECONDARY COLORS

FIGURE 1-44

FIGURE 1-42

CMY Color System

The **cyan**, **magenta**, and **yellow** color system is also referred to as the **CMY Color System**, and it is mainly used in colored printing processes.

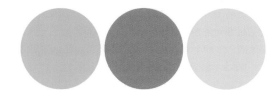

FIGURE 1-45

You may have noticed this combination while changing ink cartridges in your printer. These colors are printed as tiny dots or in thin layers to create a full range of color. The **secondary** colors of CMY are red, green, and blue.

The CMY system can be considered an updated and more effective way of mixing color than the traditional RYB system, because it follows similar concepts and uses colors that weren't available to traditional artists. The theory that cyan, magenta, and yellow are more effective primary colors is true in situations involving inks and dyes, but the problem we

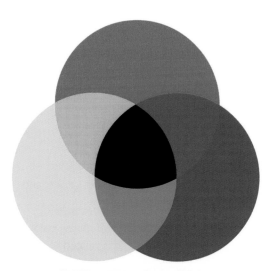

RED-YELLOW-BLUE
Primary Colors of Pigments

FIGURE 1-43

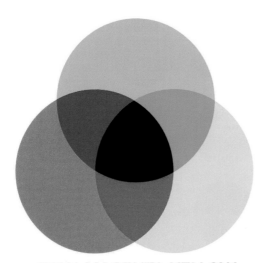

CYAN-MAGENTA-YELLOW
Primary Colors of Printing

FIGURE 1-46

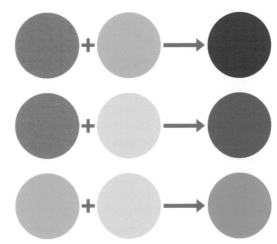

MIXING **C-M-Y** SECONDARY COLORS

FIGURE 1-47

22

have in make-up and in painting comes within the physical pigments, their binders, and the way they are mixed. These bright colors work successfully for printing because a true cyan, magenta, and yellow can be manufactured in dyes and inks, and their translucency is key for mixing new colors. Some printers work by placing colors in sequences of tiny dots using cyan, magenta, yellow, and black ink, which are optically mixed into new colors by the viewer. Other printers overlap thin translucent, and dry layers of cyan, magenta, yellow, and black for a similar effect. We achieve different results when these same colors are combined in paint (or make-up), because the pigments are mixed together when the colors are still wet, and intensity is always lost when two colors are blended. This is why the results of color mixing vary between the RYB system and the CMY system.

Traditionally, red, yellow, and blue were considered the primary colors because you cannot create any of them by intermixing any

other two paint colors. However, when using ink it is possible to create a pure red (by layering magenta and yellow), as well as a pure blue (by layering magenta and cyan).

When mixing pigments, we have to experiment by mixing the various blues, reds, and yellows on the market because there is no single perfect primary color available. We end up using principals from both RYB and CMY systems in painting and in make-up due to these pigment limitations. For example, if we were to mix a magenta paint with a yellow paint, the result would be orange, instead of the desired red that we can achieve by overlapping or optically mixing the same two colors with printer ink.

RGB Color System
In the **RGB Color System**, **red, green**, and **blue** are the primary colors.

This system is a scientific way of mixing color when using colored light and is related to color

FIGURE I-48

vision. The **secondary** colors in this system are cyan, magenta, and yellow.

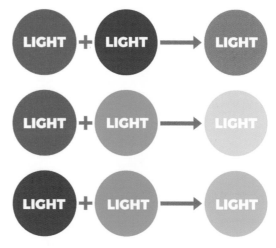

MIXING **R-G-B** SECONDARY COLORS

FIGURE I-50

23

RED-GREEN-BLUE
Primary Colors of Light

FIGURE I-49

A good example of the RGB system is the way a cell phone or television screen works. Colors are mixed together with light, so the result is white when all three primary colors are combined. A yellow is made when tiny dots of green and red light are blended. Because we work with pigments and not light, these principals cannot be applied to mixing paint or make-up colors. For example, mixing blue and yellow paint results in green paint, while mixing blue light and yellow light results in white light.

THE RGB COLOR SYSTEM IS DESCRIBED MORE IN CHAPTER 6, BECAUSE IT IS IMPORTANT TO UNDERSTAND HOW COLORED LIGHTING ON TELEVISION AND FILM SETS CAN AFFECT MAKE-UP DESIGNS.

Additive and Subtractive Color

When mixing color, it can be considered either an additive or a subtractive process. **Subtractive color** refers to the mixing of pigments and dyes. This includes both the traditional **RYB** color system, as well as the **CMY** system. Combining all three primaries of subtractive color results in black. It is called subtractive because when colors are mixed, certain wavelengths are subtracted from what we see.

Additive color refers to the mixture of light and applies to the **RGB** color system. Combining all three primaries of additive color results in white. When mixing colors

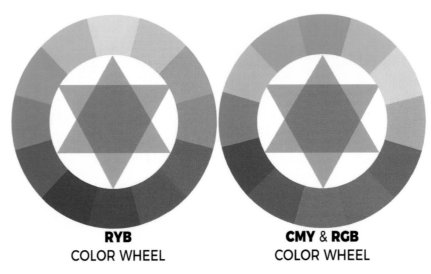

RYB
COLOR WHEEL

CMY & RGB
COLOR WHEEL

24

FIGURE 1-51

of light, wavelengths are added to what we see, which is why we consider it an additive process.

OPTICAL ILLUSIONS IN COLOR

Contrasting with Black and White

When a color is contrasted by a surrounding color, it can either stand out or appear lost. Adding black or white around a color can be a very effective design choice, because they are both colorless and will contrast in value. Adding a neutral contrast can strongly accentuate a color when executed properly. You can see how a lower value (like the yellow pictured) stands out and is defined when surrounded by black and appears to have less sharp edges when surrounded by white. A dark hue (like the purple pictured) stands out against white and becomes lost inside the black. This also explains why dark eyeliner can be so effective at making your eyes stand out, because the dark contrasts the whites of our eyes. This contrast can be an important tool to use when creating bold designs.

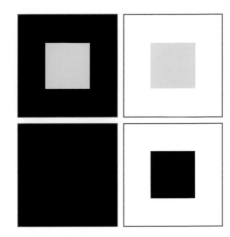

FIGURE 1-52

Simultaneous Contrast

Colors can be completely affected by their surroundings, and **optical illusions** can occur which can also affect your color choices.

When one color is surrounded by another color, our eyes perceive them differently. The first example shows that the same tan color appears much darker when surrounded by a dull, light red than it does by a dark green.

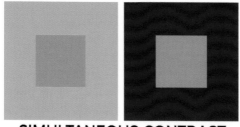

SIMULTANEOUS CONTRAST

FIGURE 1-53 The tan squares are identical, but appear different when surrounded by other colors.

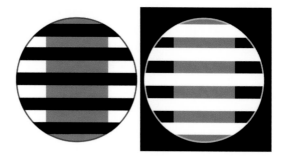

FIGURE 1-55 The grey lines in each circle are identical, but appear different based on their surroundings.

This can explain why some people look better wearing certain colors, or why our eyes seem to stand out with certain eyeshadows. This effect is known as **simultaneous contrast**. In the second example, the same shade of red looks cooler, warmer, darker, or lighter, depending on which color surrounds it.

Simultaneous contrast is not just a curious optical phenomenon—it is the very heart of painting. Repeated experiments with adjacent colors will show that any ground subtracts its own hue from the colors which it carries and therefore influences.
—Josef Albers (1888–1976)

25

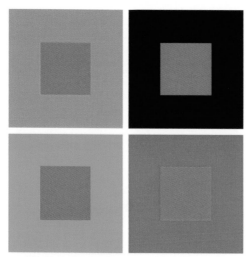

SIMULTANEOUS CONTRAST

FIGURE 1-54 The red squares are identical, but appear different when surrounded by other colors.

Notice the black, white, and grey example of simultaneous contrast. The grey lines inside both circles are identical, even though they seem significantly different in value based on their surroundings.

Optical Color Mixtures

An **optical color mixture** is another optical illusion that can occur as a result of alternating patterns of color. The phenomenon happens because our eyes naturally blend small patterns of colors and perceive new colors. This explains why we see mixed colors on digital screens,

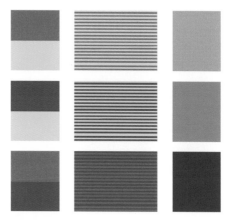

OPTICAL COLOR MIXTURE

FIGURE 1-56

even though the images are made up of tiny pixels. If you squint your eyes while looking at the example (Figure 1.56), you can see how the orange, green, and purple are created optically.

After-Images

An **after-image** is a phenomenon where our eyes create an apparition of a color's complement. This optical illusion works with every hue, value, and intensity, as well as with black and white.

Stare at the black dot in the center of the colored circle for 30 seconds. Then, shift your eyes to the black dot on the white surface. You will see a hazy after-image appear that looks just like the image of the circles, but the colors will be opposite and complementary. The complementary pairs will be those of the **RGB spectral color wheel,** because it relates to light and colored vision. Notice how your

eyes create a new circle pattern with yellow in the center (the spectral complement of blue), magenta in the middle (the spectral complement of green), and a blue outer circle (the spectral complement of yellow). This effect is suspected to be caused by **retinal fatigue**, which means the color sensors of the eye are overexposed to a certain color and become fatigued, creating an optical illusion.

In the second example (Figure 1.59), the after-image is apparent within the design. Look for yellow lines intersect on the grid. The close-up image of the grid is approximately what you will see (Figure 1.58).

Impressionism

Impressionism was a 19th century artistic movement where artists did not mix and blend color smoothly, but instead applied it in small patterns and brush strokes. Impressionists deviated from the natural color palette of

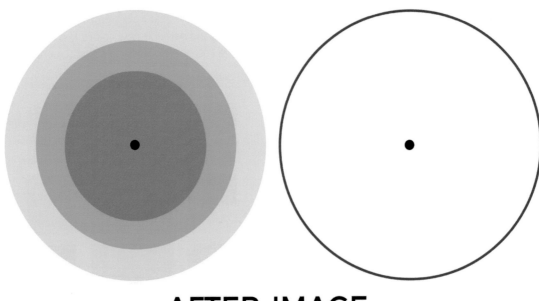

AFTER-IMAGE

FIGURE 1-57

FIGURE 1-58

FIGURE 1-59

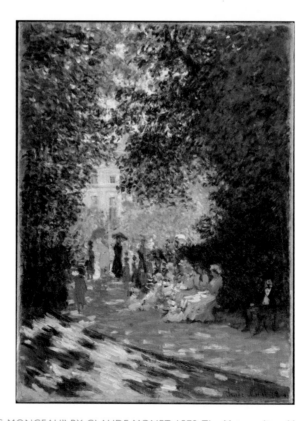

FIGURE 1-60 "THE PARC MONCEAU" BY CLAUDE MONET. 1878. The Metropolitan Museum of Art, New York.

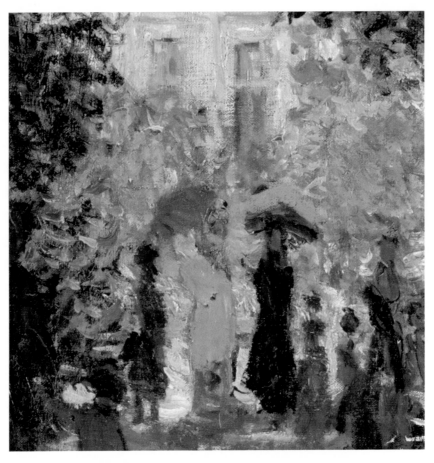

FIGURE 1-61 DETAIL OF "THE PARC MONCEAU" BY CLAUDE MONET. 1878. The Metropolitan Museum of Art, New York.

traditional painting and used bright, vibrant colors instead. The eye **optically mixes** these colors, creating different effects depending on whether you are standing closely or far away from the work. From far away, the colors seem subtle and subdued, but up close they are bold and intense. As mentioned before, purist Impressionist painters banned the use of black paint by replacing it with vivid colors to custom blend their dark values.

The principles of **simultaneous contrast** helped make the technique more effective, because specific colors could be used to achieve the desired effects. Placing complementary colors side-by-side causes them both to "pop,"

and placing harmonious colors next to each other causes them to blend. **Claude Monet**, **Paul Cézanne**, and **Pierre-Auguste Renoir** were some of the better-known Impressionist painters.

Featured is the impressionistic painting "The Parc Monceau" by French painter Claude Monet from 1878.

Pointillism is a type of **Neo-Impressionism** that took the Impressionist movement into a more scientific direction. The technique was inspired by color theory and the movement was less spontaneous than that of Impressionism. Tiny individual dots of color were placed next

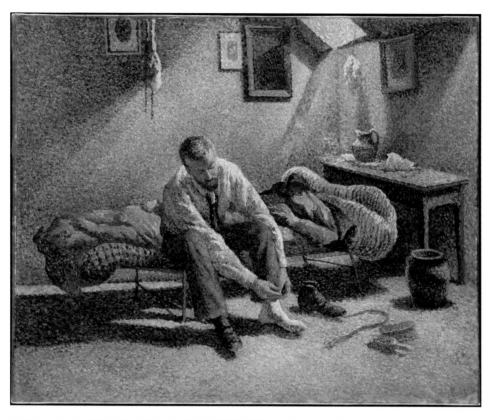

FIGURE 1-62 "MORNING, INTERIOR" BY MAXIMILIEN LUCE. 1890. The Metropolitan Museum of Art, New York.

to each other so that the eye would mix them into a desired blended color, creating an **optical mixture**.

Pointillist painter **Maximilien Luce** used this technique in his painting "Morning, Interior" from 1890. Notice in the close-up of the man's face, that the flesh colors are comprised mainly of rich colors blended by the eye. When you look at the painting from afar, the colors appear subdued and natural. Luce believed that this technique resulted in much more vibrant paintings than those where artists practiced traditional color mixing.

It is important to understand why Impressionism (especially Pointillism) is so effective, because the technique can help prevent you from creating

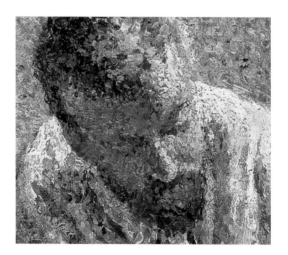

FIGURE 1-63 DETAIL OF "MORNING, INTERIOR" BY MAXIMILIEN LUCE. 1890. The Metropolitan Museum of Art, New York.

muddy mixtures of colors in situations like covering tattoos, color correction, or painting prosthetics. If you were to simply mix together many of the vibrant colors that the Impressionists used, the result would be brown. Learning to let your colors weave in and out of each other and using optical mixtures (instead of physically mixing them) will help you create more natural and attractive designs.

WHEN APPLYING MAKE-UP FOR TELEVISION, FILM, OR PRINT, THE CAMERA WILL OPTICALLY MIX COLORS SIMILAR TO THE WAY YOUR EYES DO, SO YOU CAN USE THIS PARTICULAR OPTICAL ILLUSION TO YOUR ADVANTAGE.

2

PIGMENTS AND DYES

WHAT ARE PIGMENTS AND DYES?

It wasn't always such a simple process to obtain color, since all colors that we use physically (e.g., paint, dye, make-up) have to either be found in nature or created chemically. In the past, some colors were rare and expensive because they could only be sourced from remote locations, and some were even discovered by accident. Color palettes in ancient times were much more subdued because certain brilliant colors were not discovered until later on in history. Today, we have access to countless different pigments because we have modern techniques of creating them consistently. Surprisingly, new colored pigments are still being created and discovered.

> *Color is a part of a spectrum, so you can't discover a color. You can only discover a material that is a particular color.*
>
> Mas Subramanian (Chemist, Founder of YInMn Blue in 2009)

Pigments

Pigments are what we use to create paints and other colorants, including make-up. They are materials (natural or chemical), which contain properties that reflect wavelengths back to our eyes, which we perceive as specific colors. Pigments are ground into tiny dry particles and are **insoluble**

FIGURE 2-1 FORBES RARE PIGMENT COLLECTION AT HARVARD UNIVERSITY. Photo by Andrea Shea.

(cannot be dissolved by liquids). This means they can be mixed and suspended into paint **binders** while still retaining their color properties. Paints are only able to adhere to surfaces due to these binders. For example, mixing pigments with substances like plant oils, tree gums, plastics, and even eggs can create paints. This is how we end up with different paint types, such as watercolors, oil paints, and acrylics. Not every colored material is stable, so pigments must be made using a compound that doesn't fade or change color over time.

> MAKE-UP IS FABRICATED FROM A SIMILAR PROCESS BY SUSPENDING PIGMENTS OR DYES (THAT ARE SAFE ON THE SKIN) INTO COSMETIC BINDERS, WHICH CREATE DIFFERENT PRODUCTS, INCLUDING THOSE WITH CREAM BASES, SILICONE BASES, WATER BASES, WAX BASES, AND ALCOHOL BASES.

Dyes

Dyes are similar to pigments, but they do not require a binder because the particles are **soluble** (dissolve when combined with a liquid like water or oil). Dyes can be made from similar sources like berries and insects, and can also be created synthetically. Using a dye results in staining a surface rather than coating it, so they are commonly used to color fabrics. Both pigments and dyes are used in cosmetics.

Inks are typically dye-based, where the color is fully dissolved into the liquid base. There are some inks available that are pigment-based, but the colors are not as vibrant as those made from dyes. This explains why the **CMY Color System** (Cyan-Magenta-Yellow) is the most relevant for printing, because ink is available in bright and translucent colors (like cyan and magenta), which aren't as brilliant in the comparable pigments used for paint.

Dyes can be made into pigments, but pigments cannot be made into dyes. If a

dye is bound with a **mordant** (typically a metal ion used for binding a dye to a material), then it can become an insoluble pigment.

Examples of Pigments and Dyes

The use of pigments dates all the way back to prehistoric cave paintings from the Paleolithic period (350,000 BC). Earthy browns and ochers could be found in soil and rock deposits, while white was made from chalks, and black was derived from charred remains. Even blood and rust were utilized to create paint.

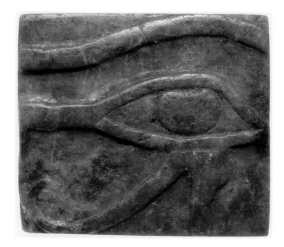

FIGURE 2-2 EGYPTIAN "WEDJAT EYE" CARVED FROM LAPIS LAZULI (664–332 B.C.). The Metropolitan Museum of Art, New York.

In the ancient world, pigments like blue and purple were very scarce and almost impossible to acquire. Egyptians controlled the supply on a pigment known as **Ultramarine Blue**, which was highly sought-after. It was mined in Afghanistan from the stone **lapis lazuli**, which was known for its unique, brilliant blue color. It required a labor-intense process to turn into a pigment, which made it incredibly expensive to import. In Europe, it was in high demand by painters such as Leonardo da Vinci, Titian, and Vermeer. Ultramarine blue was often reserved in their paintings for the clothing of royalty or important

religious figures. Today, ultramarine blue is made synthetically and it is readily available.

FIGURE 2-3 TYRIAN PURPLE DYED CLOTH. Krynochkina/©Shutterstock.com.

Tyrian Purple was another sought-after color that was made by the Phoenicians from sea snails. It took approximately 250,000 mollusks to create a single ounce of the purple dye. Because of its secret ancient recipe, rarity, and expense, the color was a status symbol and was saved for dying the clothing of royalty. This is where the term "royal purple" originated.

The Aztecs discovered a brilliant red color called **cochineal**, which was made from crushing tiny grey insects that expel a unique red colorant

FIGURE 2-4 COCHINEAL INSECT USED FOR MAKING RED DYE. Original image by Protasov AN/©Shutterstock.com. Edited by author.

from their shells. It takes at least 70,000 bugs to create a single pound of cochineal dye. Like lapis lazuli, cochineal was also imported to Europe at a very high price. It was mainly used to color fabrics that clothed the wealthy. Surprisingly, cochineal is still often used today as a food colorant, and it is also found in **lipsticks**, **blush**, and **eyeshadow**. You may find it listed under ingredients and referred to as carmine, cochineal extract, or natural red 4.

FIGURE 2-6 YINMN BLUE PIGMENT, DISCOVERED IN 2009. Photo by Mas Subramanian.

FIGURE 2-5 *BIXA ORELLANA*, ALSO KNOWN AS THE LIPSTICK TREE. Prachaya Roekdeethaweesab /©Shutterstock.com.

Annato is a red-orange colorant that is derived from the seeds of *Bixa orellana*, which is also commonly known as the **lipstick tree**. The color was used first for body painting, and today it is used in **cosmetics** and processed foods, such as cheeses and butters.

In 2009, a new blue pigment was accidentally discovered by a French chemist named Mas Subramanian. It was the first new pigment to be discovered in over 200 years. Subramanian was in the business of altering chemicals to use in electronics, and he inadvertently stumbled upon the brilliant blue. He named the color **YInMn Blue** after its ingredients: yttrium, indium, and manganese oxides. It is also referred to as "**Mas Blue**," which is not only his first name, but also the Spanish word for "more."

Pigments and Dyes in Make-Up

While painters in history were using pigments to produce their paint, others were creating make-up with them. These pigments were made into cosmetics by mixing them with binders like animal fats, vegetable oils, beeswax, and egg whites. Unfortunately, the pigments they used weren't always the safest choices. Many of these contained toxic and deadly ingredients.

Ceruse was a cosmetic used to whiten skin and was made popular by **Elizabeth I** in the mid-to-late 1500s. It provided a luminous finish, which she wore to cover her smallpox scars. Ironically, using ceruse further scarred her skin because it was made of poisonous and deadly white lead powder.

These cosmetic whitening pastes were common around the world. Toxic leads and chalks were used in areas including Egypt, Greece, China, and Japan. Traditional Japanese **geishas** would whiten their faces and necks during special performances. Whitening pastes could also be made from less threatening ingredients (like rice powder or flour), but the most expensive and desirable pastes were those created from products containing the most lead.

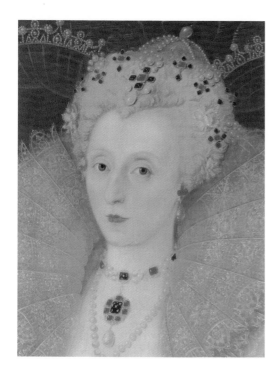

FIGURE 2-7 DETAIL OF "PORTRAIT OF QUEEN ELIZABETH I" BY MARCUS GHEERAERTS THE YOUNGER (1558–1603).

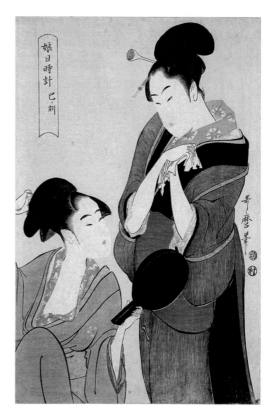

FIGURE 2-8 "JEUX DE MIROIR" BY KITAGAWA UTAMARO (1797). Attribution: Daniel Julie.

Eventually in the Victorian Era, a less-toxic **pearl powder** became a replacement for thick lead make-up and was made of talc and bismuth.

Early **rouges** were also made from ingredients found from the earth, but sometimes, earthy pigments (like red ochers) could also be toxic. Brighter reds were made from dying various red colorants into a white lead base. The Romans used poisonous **cinnabar**, while in ancient Greece they used a red-orange color called **vermillion** that contained deadly mercury. Lip pencils were also made from these reds, and they were created with a base of **ground alabaster** or **plaster of Paris**.

Once the harmful effects of lead and mercury became more apparent in the 16th century, **Spanish wool** (also known as Spanish paper) became popular. It was a small piece of cloth or paper that was stained with a dye or pigment

such as **cochineal**, **saffron**, **red sandalwood**, **geranium**, **poppy petals**, or **berries**. It was moistened and then rubbed on the cheeks or lips for a stained effect.

Pigments were also used to accentuate the eyes, and the Egyptians were best known for this. They made powdered **kohl** from grinding minerals and copper ores (e.g., green malachite, antimony) and crushing ant eggs. Burnt cork, coal dust, ash, burnt almonds, and elderberries were also used to darken lids and lashes.

Surprisingly, shimmery or glittery paint and make-up is not a modern development and was utilized as far back as the Paleolithic era. **Mica**, a silicate mineral (a salt containing silicon and oxygen found in mineral rocks), was used to add

FIGURE 2-9 MUSCOVITE MICA USED FOR ADDING "GLITTER" TO COSMETICS. Nastya Pirieva/©Shutterstock.com.

a little sparkle to cave paintings. The Egyptians took it further and added it to their make-up to create a lustrous and pearlescent look. They even added **fish scales** to their cosmetics to create a similar effect. Today, fish scales in cosmetics are referred to as **guanine**, and they are still used for iridescence in make-up, bath products, and nail polishes. Mica is also still used in cosmetics. There are other various types of glitters that are made synthetically and range from thick flecks to fine particles with a subtle sheen. Glitter can even be fabricated from glass particles to increase reflection and create a mirrored effect.

> Glitters are precision-cut shapes of brilliant glittering polyester foil, epoxy coated with light-fast dyes 'captured' in the coating. The layers act as thin transparent mirrors for rays of light; most pass through but some are reflected.
> —W.A. Poucher, *Poucher's Perfumes, Cosmetics and Soaps: Volume 3.*

Over time make-up became more socially acceptable and eventually was sold commercially, but it wasn't always as easy to obtain as it is today. During the Prohibition in America, women didn't have easy access to make-up, so they accentuated their eyes with various homemade products like **lampblack**. This was made by heating an object (like a porcelain saucer) with a candle flame to create soot. The soot

was then mixed with water or baby oil and applied to the eyes to create a smoky effect.

Early cosmetics had no tests or regulations in place. In 1917, a London-based company began adding the radioactive ingredient **radium** to their skincare and make-up line. They marketed their products, claiming that the radium would help make wrinkles disappear. In 1933, Tho-Radia products were released containing both radium bromide and thorium chloride, which both happened to be radioactive. The company pushed various products in its line, claiming to promote a "glowing" complexion.

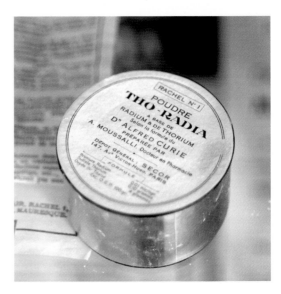

FIGURE 2-10 THO-RADIA POWDER CONTAINING RADIUM AND THORIUM FROM 1933. Photograph by Rama, Wikimedia Commons, Cc-by-sa-2.0-fr.

Luckily, in 1977, the FDA (Food and Drug Administration) passed a requirement for cosmetic manufacturers to list all ingredients on the labels, and have all color additives approved by the FDA.

Today, pigments used in make-up are mainly produced synthetically so that the quality can be controlled more easily. There are unpredictable variations found in natural products, so the synthetic fabrication aids in consistency.

This photograph from 1939 shows lipstick being created by hand in a pigment mill, which grinds the pigments and combines them with the lipstick's base. The process of creating make-up has not changed in decades for many manufacturers, and pigment mills are still used today.

Lipstick waxes and colors being mixed in a pigment mill. Manufacturing processes are duplicated in the laboratory

FIGURE 2-11 ARTICLE FROM *POPULAR SCIENCE MAGAZINE* IN 1939.

CHARACTERISTICS OF PIGMENTS

Organic and Inorganic Pigments

Pigments are considered to be either inorganic or organic, and both can be made synthetically. The ancient Egyptians were the first to synthetically create pigments.

Inorganic or **mineral** pigments contain salts and metallic oxides and traditionally were derived from the earth. Most inorganic pigments are dull, opaque, and less effective when mixed. They are predictable and more resistant to heat and light. Inorganic pigments can also be made synthetically in a laboratory where they are manufactured with metallic compounds to regulate impurities.

> INORGANIC PIGMENTS THAT ARE PURE FROM ELEMENTAL HEAVY METALS ARE USED COMMONLY IN COSMETICS AND ARE SAFE ON THE FACE AND AROUND THE EYES.

Organic or **modern** pigments are made from plants and animals. They are typically intense, translucent, and effective when mixed, but they are less stable than inorganic pigments. Today, they are often made synthetically in a chemical laboratory for consistency. The three types of organic pigments are lakes, toners, and true pigments (lakes and toners are the most common). **Lakes** are basically pigments that are created by bonding a soluble dye with an aluminum substrate, which makes them insoluble pigments. **Toners** are similar to lakes, but they are made with other safe metals that are not aluminum. A **true pigment** is extremely rare, but it is the most stable organic pigment because it does not contain any metal ions and is naturally insoluble.

Transparency and Opacity

Paint can have varying characteristics depending on which pigment it is created from. Certain pigments contain properties that affect the way

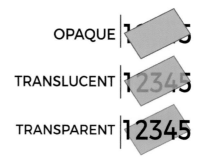

OPAQUE

TRANSLUCENT

TRANSPARENT

FIGURE 2-12

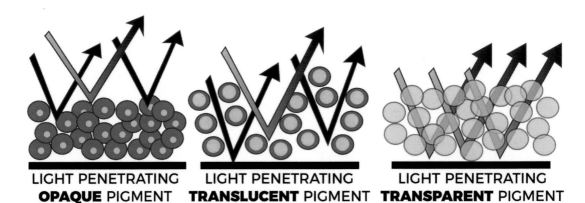

LIGHT PENETRATING
OPAQUE PIGMENT

LIGHT PENETRATING
TRANSLUCENT PIGMENT

LIGHT PENETRATING
TRANSPARENT PIGMENT

FIGURE 2-13

that they let light pass through, meaning some paints are naturally better for covering surfaces with a thick layer and some are better for glazing.

Opaque means that no light travels through an object, so you are unable to see through it.

Translucent means that some light passes through an object, so that you can partially see through it.

Transparent means that light passes through the object, so you are able to see what is behind it.

When combining two pigments (whether with paint or with make-up), you should be aware of their natural properties and whether each color is transparent or opaque. Some pigments hold their intensity better than others, and some are naturally more sheer than others. These properties will determine the outcome of how effective the mixture is at covering a surface. For example, an opaque white paint could cover a black surface, while a translucent white paint could not.

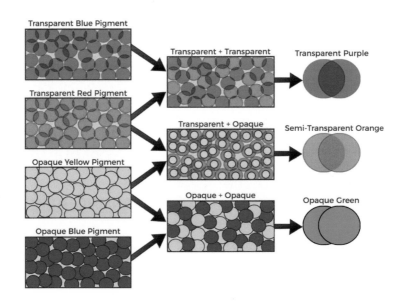

FIGURE 2-14

Pigment Variations and Mixtures

Since pigments are found and created from so many unique sources, they react in different ways when they are mixed with binders and with each other. These charts make it easier to visualize how some examples of common primary pigments react when combined.

The first image illustrates different versions of yellows, reds, and blues that are made from both inorganic and organic pigments (in oil paint). These are just a few common examples of the countless pigments available. You can see how Cadmium Red Light and Cobalt Teal are much more opaque than Phthalo Blue and Alizarin Crimson. Some colors are naturally more cool or warm, so it's important to pay close attention to these differences and be aware of a color's properties before making selections and mixtures.

When white is added to a color (also known as creating a **tint**), the natural differences are even more apparent, because each colored pigment reacts differently when combined with white pigment. Some mixtures remain vibrant, some become dull, and some appear to have characteristics of secondary colors. Notice how Prussian Blue and Phthalo Blue appear very similar on their own, but when mixed with white, Phthalo Blue is much more vibrant than Prussian Blue. A color like Alizarin Crimson looks almost black in the paint tube, but is very bright once it is thinned or combined with white.

It's important to familiarize yourself with these differences, so that you will select the correct hues when color mixing. Since pigments can either be found in nature or created chemically, our available choices are limited by physical

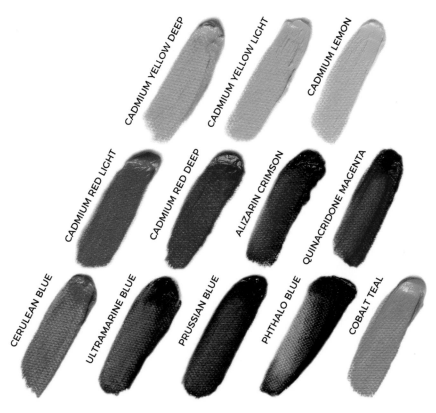

FIGURE 2-15 COMMON PIGMENTS IN OIL PAINT.

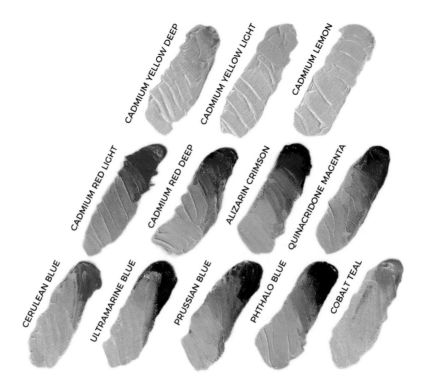

FIGURE 2-16 COMMON TINTS OF PIGMENTS IN OIL PAINT

colors that have been discovered or fabricated. As mentioned in Chapter 1, you should be able to mix every color using just blue, red, yellow, and white; but in practice it is difficult, because a pure primary red, yellow, and blue have yet to be physically created or discovered. Therefore, we must use a variety of blues, reds, and yellows when creating new hues to achieve our desired colors. Even white is made from various pigments, so you'll end up with different results, depending on whether you choose to mix with an opaque, translucent, or a non-true white that is slightly cool or warm.

Varying types of red, yellow, and blue pigments also create completely different types of the secondary colors (purple, orange, and green.)

Many **cosmetics** are made from the same pigments that are used to produce paint, but they are given different names depending

on the manufacturer. Names of paint colors (like oil, acrylic, and watercolor) are much more universal because they are typically named after the pigments themselves, so the following charts are created using oil paint for consistency.

Each chart shows the result of when a specific primary colored pigment is mixed with another and with white (Titanium White oil paint).

Green Chart

The variations are the most apparent on the green chart, mainly because the properties of blue pigments can be so different. Notice how the brightest greens are made from Cobalt Teal (close to a Cyan Blue), and the most natural and earthy greens are made from Ultramarine Blue. Before they are thinned out or mixed with white, some greens appear bright and some appear almost black.

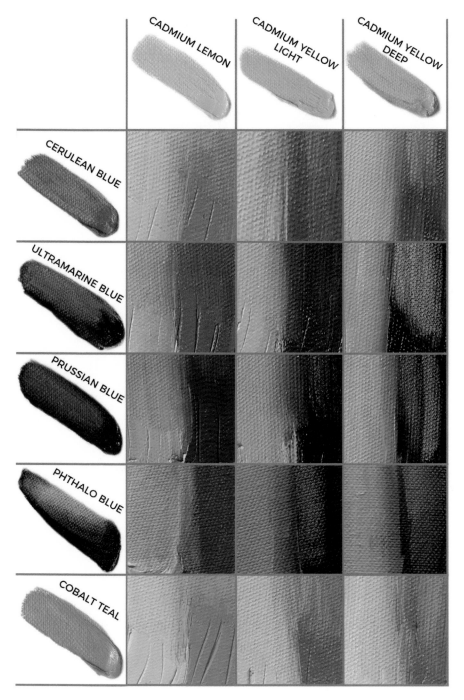

FIGURE 2-17

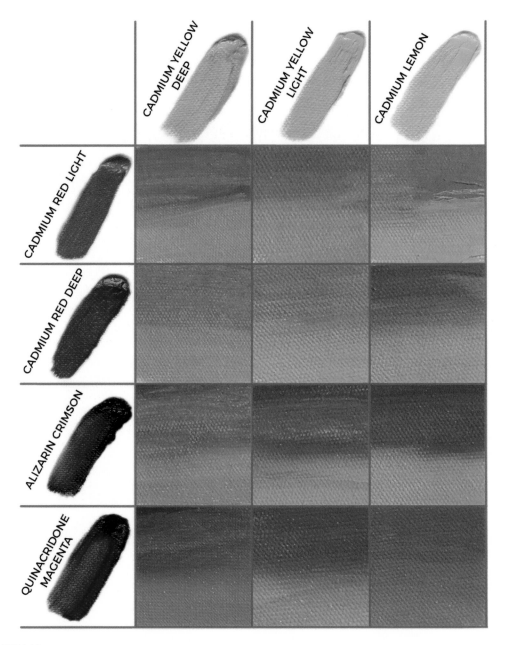

FIGURE 2-18

44

Orange Chart

In the orange chart, you can see that Quinacridone Magenta is not a good choice to mix a bright orange because it becomes greyer than most other reds. This is because it is truly more red-purple than it is red, meaning the color appears to contain more blue. Because blue and orange are complements, the extra blue qualities in the magenta dull the orange mixtures that it creates.

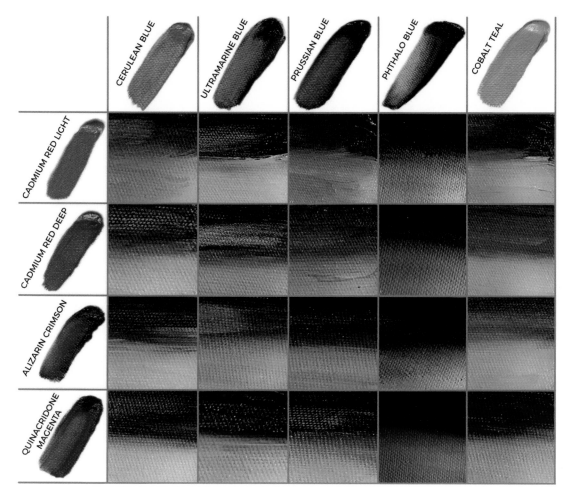

FIGURE 2-19

Purple Chart

Notice on the purple chart that Alizarin Crimson or Quinacridone Magenta make a rich purple, especially when mixed with Phthalo Blue, because they are all translucent pigments that hold their intense properties. Cadmium Red Light is not a good color choice for mixing a bright purple, because the results all appear greyed. Cobalt Teal is a similar pigment to the color cyan (a true cyan has only been made with ink, dye, or digitally), which is the complement (or opposite) of a pure red on the CMY color wheel, explaining why the mixture of Cadmium Red Light and Cobalt Teal appears very grey and not purple at all. These effects illustrate why it's important to understand properties of both the RYB color system as well as the CMY when combining pigments and dyes.

Take another look at both the RYB and CMY color wheel. Once you determine where a pigment falls on either chart, it's easier to understand why it may dull or brighten other pigments when mixed. The closer two colors are to being complementary colors, the more grey or dull they will become when combined.

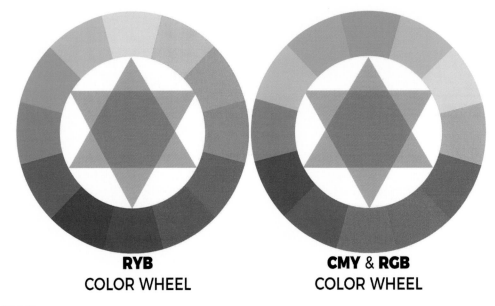

RYB
COLOR WHEEL

CMY & **RGB**
COLOR WHEEL

FIGURE 2-20

3

FLESH TONES

PIGMENTS IN SKIN

The color of our skin is determined by several factors, which vary visibly from person to person. The level of **melanin**, which is basically the pigment in our skin, is responsible for our color variations. Someone with more melanin will have darker skin than someone who has little.

Melanin also works by protecting us from harmful ultraviolet radiation and acts as a natural sunscreen. When we are exposed to these rays, our bodies produce more melanin in order to absorb the damaging wavelengths. This explains why we tan or burn in the sun. **Melanocytes** are the melanin-producing cells that are responsible for this change in pigmentation. Melanin's protective properties can prevent repetitive sun damage over time. Darker skin containing higher quantities of melanin is more resistant to these negative effects, which causes less apparent skin damage with age.

Melanin is also responsible for our freckles, the color of our eyes, and the color of our hair. The lightest blue eyes, as well as white hair, have little to no melanin present, while dark brown eyes and black hair are rich in melanin.

Melanin is not the only factor that affects the colors that contribute to our appearance. Our skin is full of blood vessels, and the redness present can fluctuate based on the person as well as other factors like physical exertion and emotions. When someone is exercising and begins to sweat, blood is pumped to the surface to supply the sweat glands, which results in a flushed face. Blood vessels, tissues, and veins can be seen through much lighter skin, which affects someone's overall coloring. This is why blushing and other shifts in color (like bruising and dark under-eye circles) are more obvious on someone who is lacking a denser layer of melanin. Levels of melanin are not necessarily uniform across a person's skin, either. The chest, face, and palms may vary in color on the same person.

The world's variations in skin colors are adaptive traits that are based on our geographical locations and how intense the UV rays are in these areas. Africans require more melanin to combat these rays for skin protection than Northern Europeans do, because of their location and the power of the sun. Our ancestors' skin adapted to conditions over time as they passed down these traits.

MAKING FLESH TONES FROM PRIMARY PIGMENTS

As a make-up artist, it's more difficult to understand how to match colors (like adjusting foundations) if you don't understand how the colors are manufactured and mixed in the first place. Learning to create skin tones by mixing only the primary colors (red, yellow, and blue) and white can be a helpful tool when faced with make-up color modifications and blending new colors. This can also help you understand what types of pigments go into your favorite make-up shades.

When determining the colors that make up a person's skin tone, use the same principals from Chapter 1 to decide their **hue**, **value**, and **intensity**. First, try to isolate the color you're trying to match. Squinting your eyes can help, or make a fist and view the subject through a pinhole to stay focused on the desired color section. You can even punch a pinhole in a white piece of paper to create a viewfinder (as suggested in Chapter 1). This can help

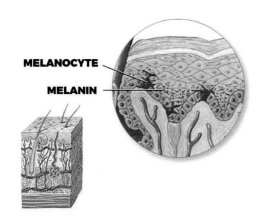

MELANOCYTE

MELANIN

FIGURE 3-1

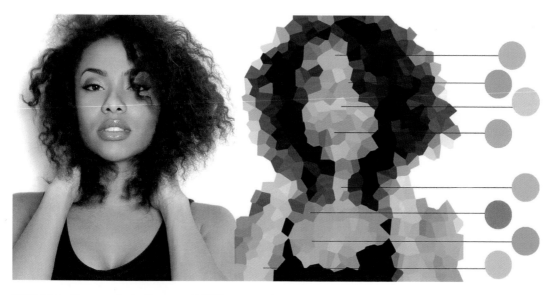

FIGURE 3-2 Photography by Protasov AN/©Shutterstock.com. Edited by author

FIGURE 3-3 MASTER CREME PALETTE BY BEN NYE.

with analyzing the actual hue, and prevent any distractions created by surrounding colors. Many faces are not one solid color, so try to identify a few colors that make up the complexion.

Once you've determined the colors that you plan to match, think about the appropriate pigments needed to create them.

> NOT ALL RED, YELLOW, AND BLUE PIGMENTS ARE CREATED EQUALLY. FOR EXAMPLE, THERE IS NO WAY OF MIXING A CYAN BLUE FROM AN ULTRAMARINE BLUE PIGMENT.

You can practice mixing these colors using pure hues with either cosmetics (like the Master Creme Palette by Ben Nye featured on page 51, or the Flash Palette by Make Up For Ever featured on page 69) or with paints (I recommend acrylic paint for beginners).

You will be using variations of the **primary colors** (red, yellow, and blue), along with **white**, to replicate skin color. See if you can match the color of your own skin, a foundation color, or a skin tone found in a magazine or online.

Avoid using black or grey, as they will quickly deaden your mixture.

Don't be afraid to mix **blues**, **greens**, and **purples** into your flesh tones. You can see how French impressionist painter **Camille Pissarro** used strokes of blue, red, and yellow in this detail from his painting "Two Young Peasant Women" from 1891–1892.

Pissarro used bold strokes instead of blending his colors, so that the eye optically mixes them together. **The colors seem bright up close, but you can see the neutralized and subtle skin tone when squinting or stepping back from the painting.**

Notice how artist David Maiden selected orange for his highlights and deep burgundy for shadows when painting a woman with a deep skin tone in his painting "Achieng".

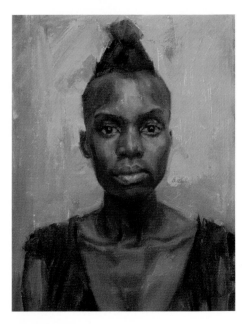

FIGURE 3-5 "ACHIENG" BY DAVID MAIDEN (2013) OIL ON LINEN.

FIGURE 3-4 DETAIL OF "TWO YOUNG PEASANT WOMEN" BY CAMILLE PISSARRO (1891–1892). The Metropolitan Museum of Art, New York

FIGURE 3-6 DETAIL OF "ACHIENG" BY DAVID MAIDEN (2013) OIL ON LINEN.

The following will show you one way to mix various
skin tones. Keep in mind there are many other ways
to mix them, and this is just one example.

First, start by mixing a **base flesh tone**.

Step 1. Most skin tones lean toward pink, red,
or golden (which are all different forms of red or
orange), so it makes sense to start by creating an
orange or **red-orange** by mixing together a red
and yellow pigment. As mentioned in Chapter 2,
there are many different reds and yellows to
choose from. You'll end up with a different shade of
orange depending on whether you choose a deep
earth red, bright red, yellow ochre, or bright yellow.

Step 2. This orange will be much too intense to
relate to a flesh color. Therefore, you'll want to
add orange's complement (**blue**) to neutralize the
mixture. This will counter the intensity of the color
without deadening it, like adding a black or grey
would. Add the blue very slowly, because it's easy
to add too much, too quickly.

Again, the type of blue pigment you choose is
important and differs with each skin tone. For
example, an Ultramarine Blue may be too dark
in a mixture for a light skin tone, and a Cyan or
Cerulean Blue may be too light to produce the
desired color for a dark skin tone. Notice in the
chart (on page 54) how different combinations of

reds, yellows, and blues result in varying flesh tones.
These are just two examples of many possibilities.

Step 3. At this point you can choose how light or
dark the value of your match should be by adding
an appropriate amount of **white**.

If you're matching a deep, rich skin tone,
you most likely will not need to add any white
at all. Try using either golden colors or bright
reds to lighten the mixture's value, because they
will maintain their intensity. Avoid adding white
until the very end, when you are certain that it
is absolutely necessary. If your dark skin mixture
needs to be even darker, try adding dark blues
and earthy reds to deepen the value. Avoid adding
black, because it can create a grey or ashy effect.

If you're matching a very pale tone, you may
want to begin with a white base and slowly add
small amounts of your base flesh tone. Otherwise,
you may end up wasting a lot of product while
trying to lighten your base mix.

Step 4. When you're satisfied with the **value**
(lightness or darkness), it will be easier to see the
adjustments that you need to make. Look closely
at the skin tone you're matching and compare it
to your color mixture. Does it need to be cooler
or warmer? Is it so intense that you need to
neutralize it even more? Maybe it's too light or too
dark. You can then add little dabs of red, yellow,
blue, and white to adjust the mixture, as needed.

Think about which different colors are visible in
the cheeks, under eyes, and even places like beard
shadows. If the person has freckles, hyperpigmentation,
or rosacea, what color would you add to make this
appear different? Try to separate all of the colors that
are present in someone's face, and create a palette
based on their complexion. For example, their cheek
color may be the same as their flesh tone mixture
with a hint of red added. You'll have to decide if the
red needs to be cool, warm, dull, or intense.

In the following charts, you can see how different
variations of primary pigments create different
base mixtures and flesh colors.

53

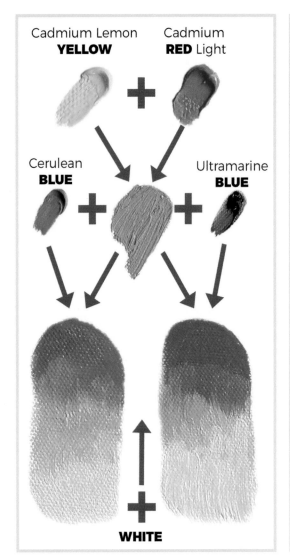

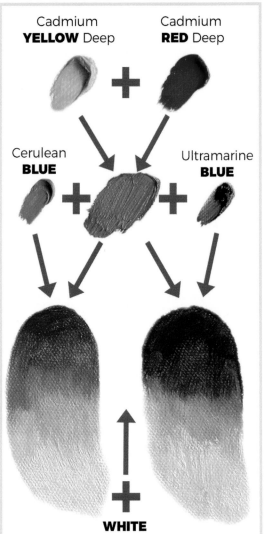

54

FIGURE 3-7

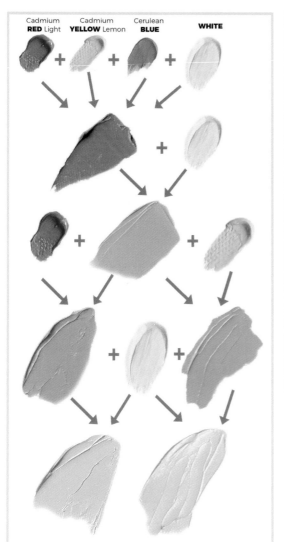

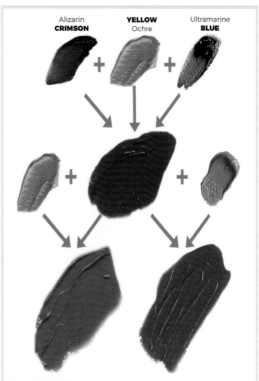

FIGURE 3-8

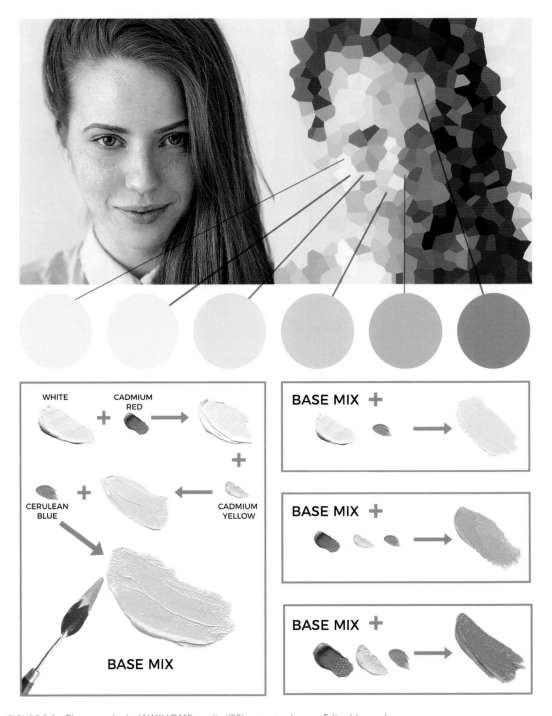

FIGURE 3-9 Photography by WAYHOME studio/©Shutterstock.com. Edited by author.

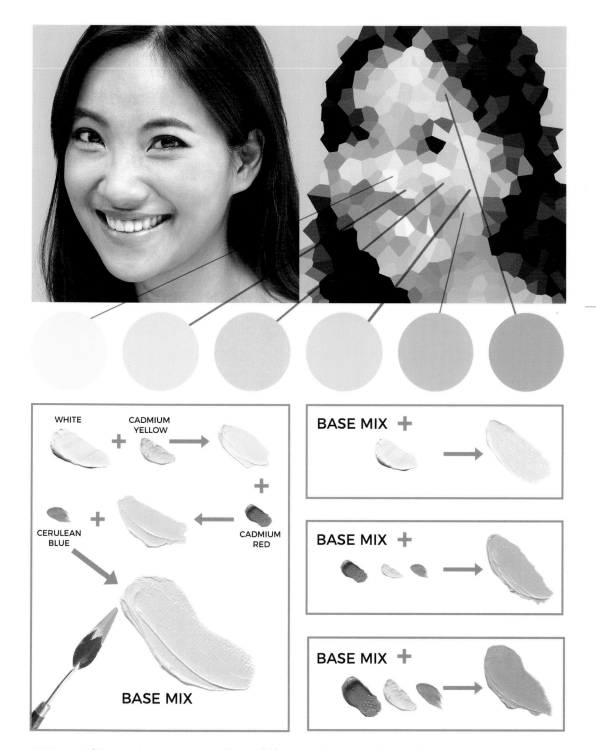

FIGURE 3-10 Photography by Apple's Eyes Studio/©Shutterstock.com. Edited by author.

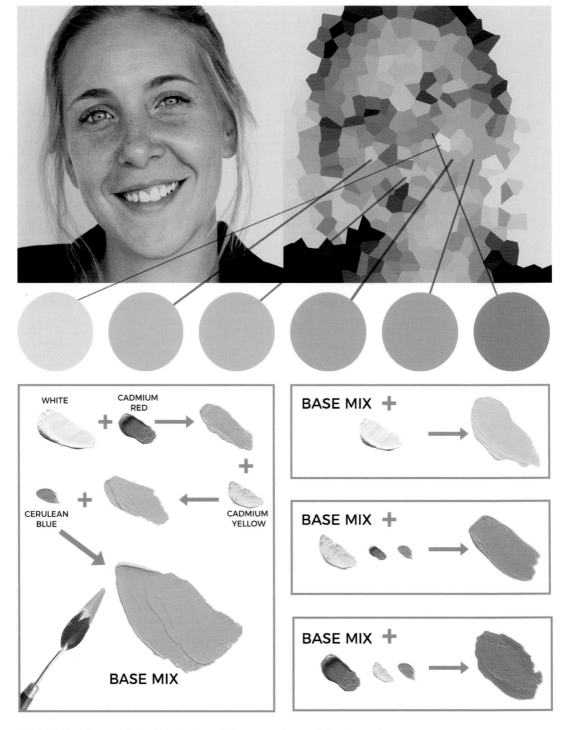

58

WHITE + CADMIUM RED →

+

CERULEAN BLUE + ← CADMIUM YELLOW

BASE MIX

BASE MIX +

BASE MIX +

BASE MIX +

FIGURE 3-11 Photography by Rawpixel.com/©Shutterstock.com. Edited by author.

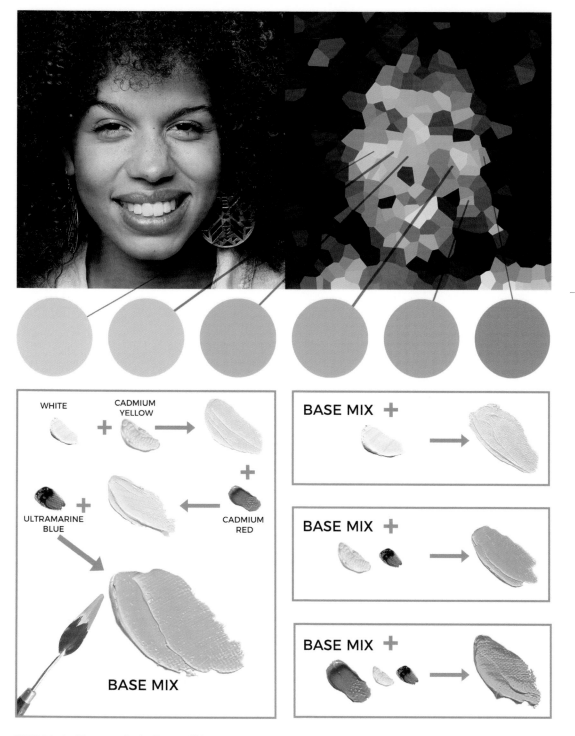

59

FIGURE 3-12 Photography by Djomas/©Shutterstock.com. Edited by author.

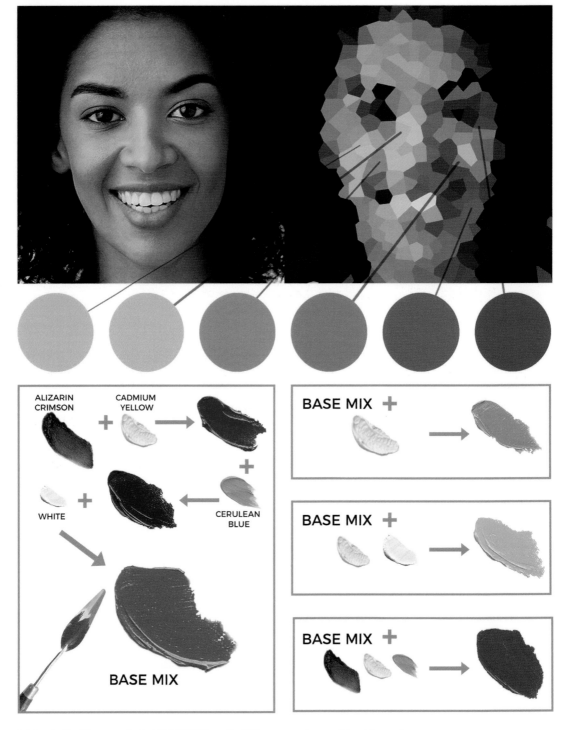

FIGURE 3-13 Photography by WAYHOME studio/©Shutterstock.com. Edited by author.

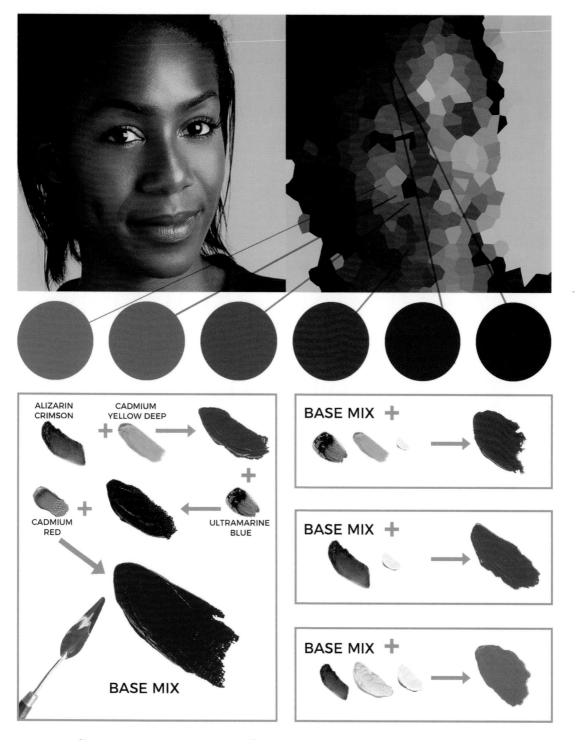

FIGURE 3-14 Photography by Anastasiia Kazakova/©Shutterstock.com. Edited by author.

4

APPLYING COLOR THEORY TO BEAUTY MAKE-UP

MAKE-UP BASE COLORS

Undertones

Before selecting make-up colors, you'll first want to determine the person's **undertone**. The undertone is the predominant color of the skin and does not relate to its lightness or darkness. In other words, it's the skin's **hue**, not its value. Think about how flesh colors are combined in the examples from Chapter 2. Did you need to mix slightly more yellow or red, or did you need extra blue to neutralize the warmth?

64

COOLER (more blue & red) **WARMER** (more yellow)

FIGURE 4-1

Look carefully, and identify the **hue** or **color temperature** of the skin the same way you identified hues in Chapter 1. This will help in determining an appropriate foundation match and aid in deciding which shadow colors, blushes, and lip colors will be the most flattering.

Undertones should fit in one of three categories: **cool**, **warm**, or **neutral**.

Even the fairest and the darkest skin can share the same temperature undertone, so don't assume that any particular person falls under one category based on their race. Disregard any preconceived ideas associated with ethnicities, and focus on the colors you can see within the skin instead.

One way that may help you determine an undertone is by looking at the veins on the inside

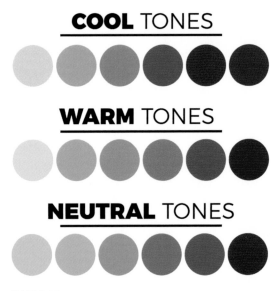

FIGURE 4-2

of the wrist. If the veins appear blue, then the person is most likely cool-toned. If they appear green, then the person is most likely warm-toned. If it is difficult to determine, then there is a good chance the person is neutral-toned. This doesn't mean that veins actually vary in color, but instead we perceive their color differently based on the way light penetrates thorough various skin tones. Make sure to perform this test under natural sunlight, because artificial light can create deceiving colorcasts.

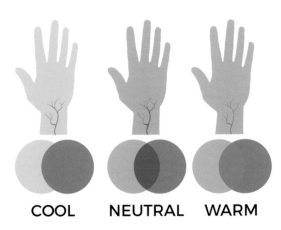

COOL NEUTRAL WARM

FIGURE 4-3

The reason veins look greener on warmer skin is because blue (veins) mixed with yellow (warm skin) creates the appearance of green. Veins under cool-toned skin remain blue or blue-purple, because there is no additional yellow visible from the tone of the skin. Very rosy skin gives the appearance of slightly purple veins because there is red pigmentation in addition to the blue that we see in veins.

> **Cool Undertones**—Bluish-pink, rosy, or blue-purple skin tones. Veins may appear blue or purple.
> **Warm Undertones**—Yellow, peachy, golden, or warm rust skin tones. Veins may appear green.
> **Neutral Undertones**—No obvious color tone. Veins may appear both blue and green.
> **Olive Undertones**—May have a slight olive green cast. Olive tones are often neutral, but sometimes are considered to be warm-toned.

Most fair-complexioned people who are sensitive to the sun and are prone to burning are cool-toned. If you tan easily and don't burn often, there's a good chance you are warm or neutral toned.

Sometimes, people test their color temperature by observing whether wearing silver or gold is more flattering. Typically, gold complements warm tones and silver complements cool tones (because gold is warm, and silver is cool). This doesn't mean a person should only wear one or the other, but it may help you determine an undertone.

If you're still having trouble deciding on the color temperature, hold a white piece of paper or a white towel next to the face. This can assist you in isolating the skin's color from outside factors and analyze the undertone more easily.

It may seem difficult to differentiate undertones at first, but eventually it will become effortless as you study and familiarize yourself with them.

Storing colors in a palette and comparing them side-by-side may make it easier to recognize the subtle differences in order to categorize them. For example, compare Graftobian's HD Glamour Crème palettes that are separated by cool, neutral, and warm. If you're a make-up artist, it can be helpful having foundation colors laid out this way so that you can hold them next to the face and narrow down your options quickly. You can also scoop any of your favorite products from their packaging and place them in empty palettes for easy access and quick color comparisons.

COOL PALETTE

NEUTRAL PALETTE

WARM PALETTE

FIGURE 4-4 HD GLAMOUR CRÈME SUPER PALETTES IN COOL, NEUTRAL, AND WARM BY GRAFTOBIAN

Foundation Matching

Foundations are intended to even out natural skin variations, so finding the appropriate match is essential for seamless blending. Again, refer to Chapter 1, where we identified a color by determining its hue, value, and intensity. We can select an appropriate foundation by breaking down a person's skin color the same way. Identifying a person's undertone is the same as determining a color's **hue**.

After selecting the correct undertone, the next step is to determine the **value** of the complexion. How light or dark is the person's skin? It's important that you have determined the correct undertone at this point, because the proper value in the wrong undertone can leave the skin looking dull, ashy, or even orange. Think about where the face would fall on the value scale and make sure your foundation is the same value. Also, be aware that oily skin can make some foundations appear darker.

VALUE

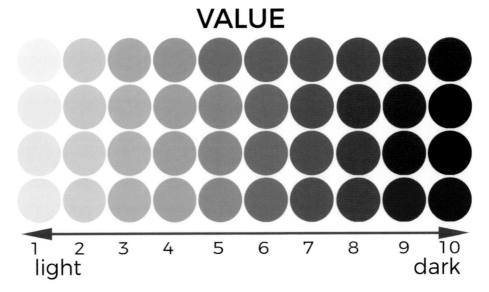

1 2 3 4 5 6 7 8 9 10
light dark

FIGURE 4-5

INTENSITY

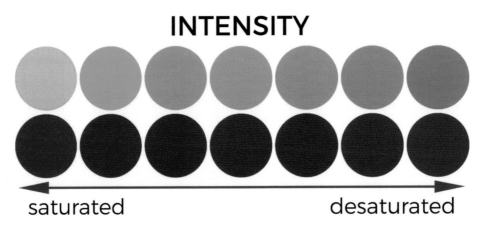

saturated desaturated

FIGURE 4-6

66

The third and last attribute of color is **intensity**, which relates to the saturation of your foundation. You may have selected the person's correct value and undertone, but the foundation may be over-saturated or under-saturated. Remember that intensity relates to how grey or dull a color is—not its lightness or darkness. For example, you may have correctly selected a warm, yellow-based foundation, but there may be too much yellow present to match the skin. In that case, you'll only need to slightly desaturate the color (by adding the color's complement).

The opposite is true with many foundations for dark skin. Sometimes you'll need a much more intense, rich, red, or golden color to keep skin from appearing dull, so you'll need to use colors with higher intensities.

Don't be afraid to test multiple shades of the same undertone at once. You'll know you've selected the correct color when it disappears on the skin. Always test your colors on the face or neck, because the wrist or body colors can be very different. If the neck is lighter or darker than the face, you can bring the foundation color down onto the neck. You may also prefer to match the neck color and blend it up onto the face depending on the person and their coloring. Also, don't assume there will only be only one color to match per face. Some faces vary from light to dark in certain areas, so you may need to blend multiple colors onto the face and neck. It is also common in people with darker skin to have lighter areas in the center of their face, so pay close attention to these variations.

If you'd like to simplify your make-up kit in order to carry less premade colors, make sure you have different values in every undertone. You don't have to own every shade as long as you carry enough options that can be combined to account for every skin tone. For example, if you need a medium warm color, make sure you have a light warm color and a darker warm color. Do the same with your cools and neutrals. Of course,

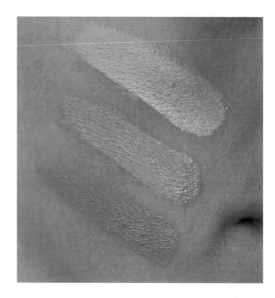

FIGURE 4-7

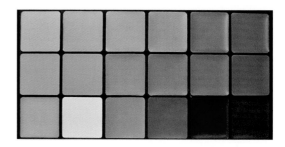

FIGURE 4-8 KJB COMPLEXION PALETTE BY RCMA

you can mix colors with different undertones, too. Just be aware that will affect the base color and can dull certain foundations.

Another way of simplifying your make-up kit is to have color **adjusters**, like primary hues, to create exact color matches using the lessons from color theory in Chapter 1. You can add yellow adjusters for warmth, red for rosiness, and blue can be added to neutralize orange. You can also keep white in your kit to lighten the value if needed to create the perfect blend.

Featured is RCMA's KJB Complexion Palette (designed by Emmy Award-winning make-up artist Kevin James Bennett). Countless skin tones can be mixed using a single palette, because it includes the primary hues and white.

If you need to adjust a neutral base so that it's warmer or cooler, it's simple to add yellow, red, or blue accordingly. However, what if the color base you're starting with is not neutral and does not match the skin because it is already too red, yellow, or blue? It's very important to understand **how to neutralize unwanted colors** to create a suitable blend.

For example, if you have a fair-skinned person with yellow undertones, and the **foundation is too pink**, your initial reaction may be to make it warmer with a yellow. However, if you think about the lessons in color theory, you'll remember that when mixing a tint of yellow and pink (a tint of red), the result will be a tint of orange which will create an unnatural skin color. Instead, you'll want to neutralize the pink. The complement of pink (tint of red) would be green, so you should add a touch of green. Then, see if this new mix matches the skin. Only start adding yellow if you still need added warmth after you've neutralized the red.

Here's another example: If you have olive skin and your **foundation is too yellow**, you should add a hint of purple to neutralize the yellow. If you simply add green, assuming that it needs to be more olive, your result will be a sallow yellow-green foundation.

Is your **foundation too orange**? Add a hint of blue to neutralize it. Just add it slowly, because it's easy to overcompensate.

Keep a color wheel nearby if you're still familiarizing yourself with opposite or complementary colors. Also, study these muted versions of the color wheel. They can be helpful references because the colors relate more closely to those found within skin.

Bear in mind there is a variety of pigments available for your mixtures, so you should carefully select the version of each hue. For example, if you need to add blue, a dark Ultramarine Blue will give you a much deeper result than a bright Cyan Blue. Magenta will be brighter than a primary Cadmium Red, and Yellow Ochre will be deeper than a bright Lemon Yellow. This is because each color has a different value at its peak intensity. Therefore, when mixing blue into a fair skin tone, Cyan Blue or Cobalt Teal will most likely be a better choice than Ultramarine Blue, because they will not deepen the value. For dark skin, Ultramarine Blue would typically be more effective than Cyan Blue. Familiarize yourself with the effects of each color by practicing mixing skin tones.

Be sure to use intense colors when using adjusters for dark skin. The high intensity is

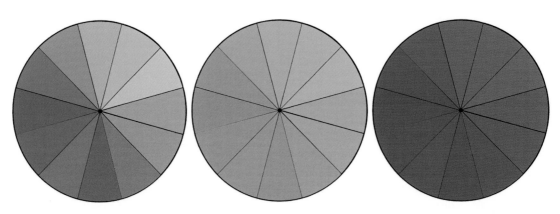

FIGURE 4-9 MUTED COLOR WHEELS.

68

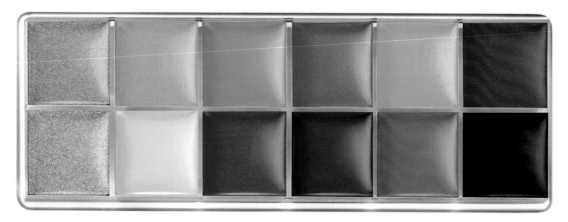

FIGURE 4-10 12 FLASH COLOR CASE BY MAKE UP FOR EVER

important, because it means the colors aren't dulled with white or grey, which will help prevent your mixtures from appearing ashy on the skin. You'll also want to avoid talc or any powders containing white for the same reason. An ashy or dusty effect can also occur on dark skin when the foundation is too light or too pink.

Using a palette with pure, intense colors (for example, this featured Flash palette by Make Up For Ever) will not only provide adjusters, but will also allow you to create almost any color imaginable. Both sets of primary colors from the RYB (Red-Yellow-Blue) system and the CMY (Cyan-Magenta-Yellow) system are included, which is enough to create foundation colors, blushes, lipsticks, and eye colors. You can reference the color breakdowns in Chapter 3 as a guide on which colors to mix.

Translucency and Opacity
When make-up contains a much higher concentration of pigment and covers skin effectively, it is considered **opaque**. A sheer wash of color is considered **translucent**. The ability make-up has to cover a surface does not necessarily correspond with its texture, but instead the percentage of pigment it contains.

It's important to familiarize yourself with different consistencies of make-up so that you can select one with an appropriate base or binder, depending

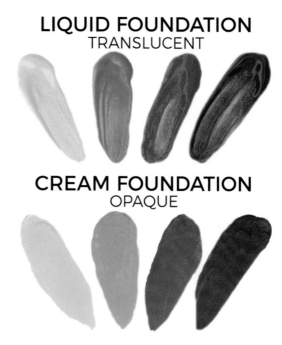

FIGURE 4-11 THE CREAM FOUNDATION HAS A HIGHER CONCENTRATION OF PIGMENT MAKING IT MORE OPAQUE THAN THE LIQUID FOUNDATION. Liquid: Ultra HD Foundation by Make Up For Ever, Cream: RCMA Cream Foundations.

on your goal. This way you'll know which product to have ready, whether you prefer full coverage or simply want to add a slight hint of color.

Tinted moisturizers have very little pigment added, so they create a subtle wash of color.

Liquid foundations can vary in pigmentation, but are typically much more sheer than **cream foundations**. Cream foundations spread on the skin opaquely, and can be thinned as needed. Each brand has a different formula, so it's important to understand a product's properties in order to use it effectively.

You may decide to use a full-coverage cream foundation, but realize that the entire face doesn't need to be covered uniformly. Cream bases can be a great option because full-coverage foundations can be blended and built up in different locations depending on the areas that need coverage.

Sometimes, you may decide to **thin out a product** to apply sheer wash or even run it through an airbrush. It's important that you first learn what type of base or binder the product contains before choosing an appropriate thinner. For example, many cream foundations have wax bases, so you'll want to use a thinner that also has a wax base. Many liquid foundations have silicone bases, so you'll want to use a thinner that has a silicone base. You'll only want to thin a product with water if it is water-based. Thinning your make-up with the wrong base can create the same problems that mixing oil and water would. Make-up can also be thinned by simply using a moisturizer; however, make sure you're not using a water-based moisturizer with an oil-based make-up or vice versa.

Layering Colors

You may have finished applying a face of foundation, and then realized that overall it feels slightly too yellow, pink, light, or dark. Maybe it's a perfect match to the skin, but you'd prefer to warm up, darken, or lighten the complexion. Instead of starting over and changing the foundation color, you can set it by using a colored powder to add a hint of color. This way, you can layer colors to achieve slight adjustments without altering the base that you've created.

FIGURE 4-12 THIS RCMA THINNER IS SPECIFICALLY FORMULATED AS AN ADDITIVE TO THEIR CREAM FOUNDATIONS. THIS IS ONE OF MANY TYPES OF THINNERS AVAILABLE. MAKE SURE TO READ YOUR LABELS BEFORE CHOOSING A PRODUCT WITH THE APPROPRIATE BASE.

Colored Powders

When setting or touching up your make-up with powder, you have the option to choose the **opacity**, which is determined by a product's **pigmentation**. The wrong powder can ruin a good foundation choice, but the right one can accentuate it. Some powders just block oil and add no color, while some contain enough pigment to stand alone as a foundation.

No-color powder is exactly what it sounds like. It appears white, but sets make-up without adding color. Be careful not to confuse it with a white or light translucent powder, which can add a slight white cast because it contains colored pigment. They both look similar when packaged.

Translucent powders also come in a variety of colors. As you will recall from Chapter 1, translucent means semi-transparent. This allows some light to pass through it, meaning this type of powder is sheer. Using a translucent colored powder is a great way to add a tiny bit of color without changing the foundation.

FIGURE 4-13 FEATURED IS RCMA'S NO-COLOR POWDER AND A LIGHT TRANSLUCENT POWDER. BE SURE TO READ THE PACKAGING CAREFULLY WHEN SELECTING POWDERS BECAUSE THEY MAY APPEAR ALMOST IDENTICAL. HOWEVER, THE TRANSLUCENT POWDER CONTAINS PIGMENT AND THE NO-COLOR POWDER DOES NOT. THE NO-COLOR POWDER CAN WORK ON ANY SKIN TONE, BUT THE LIGHT TRANSLUCENT COLOR CAN APPEAR ASHY ON DARKER SKIN.

FIGURE 4-15 THE BANANA YELLOW POWDER IS TOO LIGHT FOR THIS SKIN TONE, WHILE THE GOLDEN OCHRE WORKS WELL FOR THE LIGHTER AREAS, AND THE RUSTY BROWN WORKS WELL FOR THE DARKER AREAS.

earthy-orange, a rusty red-brown, or a maroon brown. Look closely at the skin and see which of these colors is more prominent. Be selective about which brands you're using, because unfortunately, some manufacturers don't carry rich enough colors in darker shades, and some undertones can be difficult to find in the darkest shades.

Opaque powders are packed with colored pigment and have a full-coverage effect. These can be used alone as a foundation, or when extra color is needed.

Illuminating powders are formulated with light-reflecting properties that add a shimmery look to your make-up.

Concealers

When a foundation alone is not strong enough to cover unwanted color, you may need a **concealer**. Concealers are typically thicker than foundations and have stronger pigmentation. They work well to hide under-eye discoloration, as well as blemishes.

Concealers can be the same color as foundations. However, many times they should contain a hint of a different hue, depending on what needs to be covered.

FIGURE 4-14 Photography by Chursina Viktoriia/©Shutterstock.com. Edited by author.

A **banana yellow** powder is popular because it warms up the overall skin tone and can appear less dull than a cool or white color. The yellow is also effective because it can help tone down redness, as well as neutralize purple discoloration. Keep in mind that you may want to stick with a translucent white or pink-based powder for light skin with very pink undertones. Otherwise, it may appear too yellow and unnatural.

For deep skin tones, a banana yellow may be too light and ashy, so try a rich yellow ochre, an

FIGURE 4-16 STUDIO CONCEAL AND CORRECT BY MAC COSMETICS

Yellow-based concealers help cover redness and purple discoloration.

Peach or salmon concealers help counter blues and browns, especially under the eyes.

The skin under the eyes is much thinner than the rest of our skin, so discoloration is more apparent than it is in other areas. Some people prefer a color that is lighter than their foundation to brighten the under-eye area, but on many skin tones this may not appear natural. First, try matching the under-eye color to the foundation. If it still looks too dark, use a more saturated color with a hint of a corrective color. Color intensity can be more effective at brightening the under-eye area than a color that is lighter in value. Focus on the look you're trying to achieve, and don't be afraid to experiment with a few different concealers to determine which result you like best.

For medium and dark complexions, you'll want to use concealers in the yellow ochre, orange, and

red-orange family. These can help eliminate dark spots without appearing dull.

Color Correction

If your concealer isn't strong enough to cover a certain area, layering colors by using principals of **color correction** can be a helpful tool. Some colors are more stubborn to conceal (e.g., tattoos, bruises, brown spots), so it's important to understand how color theory works with color correction. However, don't always assume you need to color correct an area, because many times concealers are pigmented enough on their own, and you may decide it's better to avoid layering unnecessary products.

If you determine that you need to color correct, you'll be using **complementary colors** to cancel out the unwanted colors. In your first layer, you'll want to neutralize the color with a color corrector. The second layer will be the natural flesh color that you're trying to achieve. As you will recall from Chapter 1, when you

FIGURE 4-17 FEATURED IS THE HD CRÈME GLOBAL CORRECTOR SUPER PALETTE BY GRAFTOBIAN, WHICH INCLUDES ADJUSTER SHADES, SUCH AS GREEN, ORANGE, YELLOW, RED, AND PURPLE TO CREATE ANY CORRECTOR COLOR.

FIGURE 4-18

neutralize a color with equal amounts of its complement, the result is grey. Grey is obviously not a desirable skin color, so be careful when color correcting in order to keep a healthy skin tone.

Choose a corrective color to place on top of the discoloration. This should effectively neutralize the unwanted color, but it will result in an unnatural skin color. To tone down your corrector, you can **stipple** (or lightly press and stamp) a foundation color on top in order to bring back the natural skin color. Be careful not to press too hard and mix the two colors, or you may end up with a muddy or dull result. Depending on the type of products you use, you may want to seal your corrector color before adding any layers so that the colors don't blend.

When selecting correctors, you should use colors with similar **values** (lightness or darkness) to the skin tone.

Red Discoloration
(Blemishes, blotchiness, rosacea)
Green will neutralize unwanted redness. Keep in mind that adding green to red results in grey, so you may prefer a color with less blue, like **yellow**, to keep the warmth in the face. Completely

removing the pink or natural flush can result in an unhealthy appearance.

Blue Discoloration
(Under-eyes, beard shadows, bruising, tattoos)
Orange, **peach**, or **apricot** will neutralize a blue or blue-grey cast.

Blue-Purple Discoloration
(Under-eyes, bruising)
Yellow-tinted correctors will help conceal purple colored areas.

Brown Discoloration
(Dark spots, under-eyes, sun damage)
Brown discoloration can be warm, cool, or neutral, so the correctors can vary. Typically a **pink**, **mauve**, **peach**, or **orange** color will be effective, depending on the skin tone and the hue of the brown.

Yellow Discoloration
(Sallow skin)
A hint of **lavender** can help counter unwanted yellow in the skin.

Grey or Dull Discoloration
Red or **pink** will add rosiness to grey or dull skin and help bring life back to it.

Tattoo Covers
Tattoos can be challenging to cover, because typically you need to conceal dark, opaque colors (like blue-black). Many times one product is not strong enough to hide a tattoo on its own.

Color correcting and neutralizing the unwanted color will help to smooth the process. If your tattoo is blue-black, first counter it with a **peachy** color or a shade of **orange**. This may look strange at first, but you'll notice if you add a flesh color on top of the orange it will blend easier than it would on its own. If your tattoo is mostly red, you'll want to counter it with a green. Use the color wheel to determine the complementary color of the hue most present in the tattoo. This color will be what you use as a color corrector.

73

COLOR CORRECTORS

DISCOLORATION

FIGURE 4-19

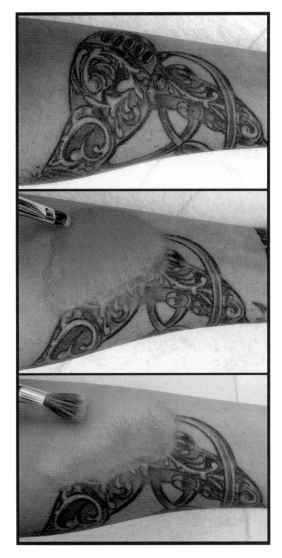

artists like to add a final thin layer of a foundation color (with a sponge or with an airbrush) to tie everything together, and you can even top it off with a colored powder if necessary.

You should either seal your make-up over the corrective color layer, or use a product like an alcohol-based make-up so that it is completely dry in between layers. Otherwise, your corrective colors may blend with your foundation colors, leaving you with a mess.

Covering or Creating Beard Shadows

Most of the time, you won't need to completely cover a beard shadow, but some specific looks and characters require it. A foundation is usually strong enough to cover some of this, but sometimes you'll be expected to remove any trace of the shadow. Again, this is where color correction can be helpful.

If you look closely at a beard shadow, you'll notice that it's mainly a cast of blue or blue-green and brown. Similar to the tattoo cover technique, you should use an **orange** or **peach** to counter the blue/blue-green. First, layer the orange or peach, seal it, and finally add a layer of the foundation color.

FIGURE 4-20 COVERING A TATTOO COVER USING COLOR CORRECTION.

Once you've placed your corrector, select a few foundation colors visible in the person's skin tone and layer them. Pick a color that matches the base tone, as well as colors that work as natural highlights and shadows. It's helpful to **stipple** layers of color or **spatter** them with a brush to add texture for a more natural look. (This is discussed in more detail in Chapter 5.) Some

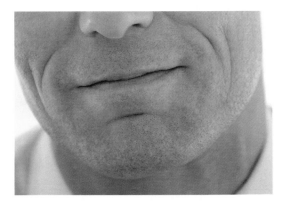

FIGURE 4-21 BLUE AND BLUE-GREEN CAN BE SEEN IN A BEARD SHADOW. Original Image by Potstock/©Shutterstock.com. Edited by author.

What if you need to create a beard shadow instead? A common assumption would be to use a light wash of brown or black, but as mentioned you should notice that beard shadows appear very blue. If you begin with a **wash of a dull light blue** or **blue-green**, you will achieve a much more natural look. Then take a fine stipple sponge and add variations of browns over the top of the wash to mimic hair follicles.

Shadows and Highlights

Contouring is basically a make-up artist's way of adding shadows and highlights. This technique originated because bright lights in theater and film heavily washed out an actor's features. Make-up artists needed to redefine their faces by contouring with make-up. This became helpful especially in theater, because expressions could be accentuated so that the audience could see them. Contouring can also be a fun tool to utilize in dramatic photography shoots. While it's still common practice in theater, contouring is much more subtle today in film because high-definition cameras pick up a multitude of details. It's important to blend everything naturally so that the make-up doesn't appear obvious.

Highlighting gives the illusion that something is coming forward. **Shading** sets an object backward. This process allows a make-up artist to be selective on what to accentuate or hide, so that the camera reads the face the way they prefer.

> WHEN SELECTING COLORS FOR SHADING, REMEMBER THAT YOU'RE BASICALLY TRYING TO REPLICATE A REAL SHADOW. SHADOWS ONLY APPEAR DARKER AND LESS SATURATED BECAUSE THEY'RE RECEIVING LESS LIGHT.

HIGHLIGHTS
examples

SHADOWS
examples

FIGURE 4-22

For a natural shadow, you'll want to select a cooler, less intense color. Don't use a bronzer to make shadows, because they are typically too saturated. Bronzers are made to accentuate the warmth in your skin, so many times they are too rich to use for contouring.

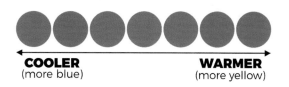

COOLER
(more blue)

WARMER
(more yellow)

FIGURE 4-23

Squint your eyes, and observe the color of your skin in shadowy areas (e.g., underneath your chin). Shading colors are typically sold as cooler browns, but they range in warmth, so pay close attention. Select a shade that reflects the color temperature of your skin. For example, if your skin is cooler, pick a shade with a little more blue in it. Experiment with a few colors and see what blends best as a shadow.

To create your own contour shadow colors, start with the person's foundation color and neutralize it by adding a hint of blue (one that is a little darker than the foundation). This will create a natural and soft neutral color while slightly darkening the mixture. Adding a hint of black is also an option, but be careful when using black because it can quickly create a dull, grey, and lifeless color.

To highlight light and medium skin, you can use colors that are lighter than your skin tone. You can create your own highlighter by choosing a foundation color or a concealer that shares the same undertone as your base and is lighter in value. You can also control the opacity by selecting different products. For example, using a less-pigmented foundation will give you a subtle sheer highlight, while using a thick concealer will give you an opaque highlight.

When choosing highlight colors for darker skin, consider intense colors over lighter-valued ones. Refer to David Maiden's painting "Achieng" (featured on page 52) to see how he chose highlights like orange instead of a light brown. Typically, warmer saturated highlights (e.g., yellow ochers, oranges, and rusty reds) appear more natural on dark skin.

Illuminators can also be added to highlights to reflect the light for a more dramatic glow. Larger particles will result in a glittery effect, while smaller particles appear shimmery.

Tip 1: If someone has puffy under-eyes, adding a lighter shade of concealer can actually make the puffiness look worse. Highlighting an area creates the illusion of bringing something forward, which can make protruding eye bags more apparent. In this case, you should match the under-eyes to the value of the foundation.

Tip 2: If you're contouring for an every day make-up look, be conscious that contouring was originally intended for harsh theater and film lighting, so be subtle. Many times, make-up tricks

that read successfully on-camera are unforgiving in person.

The Flesh Tone Color Wheel

Make-up artist and educator, Terri Tomlinson, created The Flesh Tone Color Wheel™ in 2017 as a tool to help her students relate color theory to directly working with skin tones. It works as a reference and a guide for selecting skin colors, highlights, contour colors, and their complements. Consider keeping this wheel by your side while training your eye to understand color. You may find it more helpful than the traditional wheel because the colors can be compared directly to make-up and skin.

ADDING COLOR: EYES, CHEEKS, AND LIPS

There are no real rules when adding color to the eyes, cheeks, and lips, but understanding the effects colors have on each other can be helpful when making successful selections. This is where you can have fun with the "artist" part of "make-up artist." However, if your intention is to create a natural or "no make-up" look, then it's important to coordinate make-up colors with the natural coloring of the skin.

Eyeliner

Eyeliner is typically added around the eyes in order to accentuate them. If you recall the effects of **simultaneous contrast** from Chapter 1, you should remember that certain colors create optical illusions when surrounding other colors. By contrasting opposites (like black and white or complementary colors), you can choose what features you prefer to emphasize.

Colors like black, dark brown, and dark grey are commonly used for eyeliner because the dark value contrasts with the whites of our eyes, which draws attention to them. Black is often used because it is bold against white (because they are opposites), and black will pair with any eyeshadow color because it is **achromatic** (neutral).

FIGURE 4-24 THE FLESH TONE COLOR WHEEL™ BY TERRI TOMLINSON. Image courtesy of Terri Tomlinson Makeup Training Academy.

However, sometimes black can appear harsh on people with very light skin, hair, and softer features, so a soft grey, brown, or taupe can be a better choice for a natural look.

If your intention is for the color of the eyes to stand out, you can try experimenting with **complementary colors** to contrast the eyes with eyeliner. As mentioned in Chapter 1, when you place two complementary colors next to

each other, they make the opposing color "pop" or **stand out**.

Contrasting Blue Eyes
The complementary color of blue is orange, so a color in the orange family should help accentuate the eyes. Typically, eyeliner is a darker shade so that it stands out against the white of our eyes, so a bright orange may not be deep enough in value to create the desired contrast. Using a **warm**

FIGURE 4-25

FIGURE 4-26 Photography by WAYHOME studio/©Shutterstock.com. Edited by author.

orange-brown, warm gold, or copper will emphasize blue eyes and create definition around the white. Notice in the example that the blue eyes appear more vibrant against the warm brown liner than they do against blue liner.

Contrasting Green Eyes

The complementary color of green is red, but red is not necessarily a desirable eyeliner color, because it can make the skin around the eyes appear irritated (however, don't rule out red eyeliner for this reason if you're creating an artistic or fashion-inspired look). Instead, try something in the red family like a **dark red-violet**, **purple**, **red-brown**, **reddish-gold**, or **copper**. Notice in the example that the green eyes appear more vibrant against the purple liner than they do against green liner.

Contrasting Brown or Hazel Eyes

When working with brown or hazel eyes, the first step is to determine what **hue** (or color) is predominant in the brown. If the eyes are a yellow-golden brown, their complement will be in the purple family. If they are a reddish-brown, their complement will be in the green family. If they are a green hazel, their complement will be in the red family.

When choosing an eyeliner color, keep in mind the person's skin tone and the overall look that you are trying to achieve. Sometimes a subtle neutral taupe or brown is effective enough to line and accentuate the eyes without being too noticeable, because it can appear to be a natural shadow. While a violet may complement green eyes, it could also be unflattering to some skin tones or even clash with a lipstick or an outfit.

> KEEP IN MIND, IT CAN BE MORE IMPORTANT TO COORDINATE EYE MAKE-UP COLORS WITH A PERSON'S SKIN AND HAIR COLORING RATHER THAN CHOOSING A COLOR SOLELY BASED ON THEIR EYE COLOR.

Also, consider adding color to the waterline directly below the eye. A dark color on the waterline will give the most dramatic contrast against the whites of the eyes, and give an intense, bold look. However, it will also give the appearance that the eye is smaller because it is so tightly defined. To give the appearance that the eye is more open, line the waterline with a white liner, because it gives the illusion that the whites of the eyes are extended, which makes them appear larger. If the waterline is naturally red, correcting it with a flesh-toned eyeliner will give a more natural look than white, while still opening up the eye.

FIGURE 4-27 Photography by WAYHOME studio/©Shutterstock.com. Edited by author.

Keep in mind that eyeliner is created with pigments and binders just like any other type of make-up. If you're using an eye pencil created with wax, expect a smoother and softer look than you would with a highly pigmented and sharp liquid eyeliner. The pigments within a pencil will blend and spread, while a liquid binder will keep pigments concentrated, opaque, and difficult to thin.

Eyeshadow

There are no limitations to **eyeshadow colors** you should use. There are, however, some color effects that you may want to consider when selecting your preferred shade.

For **natural-looking eyes**, you can use similar shadows to the colors that work best for highlighting and shading. Matte, neutral,

ashy browns work well to create shadows and accentuate the eyes while giving a "no make-up" look on camera.

Cool colors tend to look more natural on cool skin tones, while warm shadows blend nicely on warm tones. However, if you want your color to stand out, you may want to mix it up.

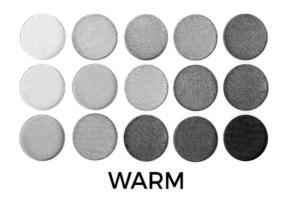

WARM

FIGURE 4-28

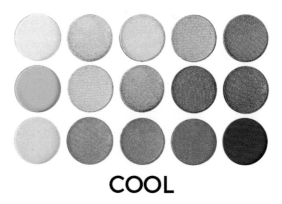

COOL

FIGURE 4-29

Complementary colors can be effective with eyeshadows, too. Image 4.30 shows how a warm, orangey shadow accentuates the model's blue eyes, making them stand out. This contrast works with bronzes, coppers, and warm browns, too.

With green eyes, try rosy colors, pinky-browns, or purple tones.

Typically, we contrast colors with their complements from the Red-Yellow-Blue color system that deals with pigment mixing.

If selecting a color for contrast you should also think about a color's complement in the Cyan-Magenta-Yellow system or Red-Green-Blue system, where the complements are slightly different, but also create a high-contrast.

FIGURE 4-30 COMPLEMENTARY COLORS: AN ORANGE EYESHADOW CONTRASTS THE MODEL'S BLUE EYES.
Photo by: Mary Costa, Make-up by: Rachel Nicole, Model: Tricia Pain.

R-Y-B (Pigment Mixing) Complementary Color Pairs:

Red and Green
Yellow and Purple
Blue and Orange

C-M-Y (Printing) and R-G-B (Light Mixing)
Complementary Color Pairs:

Cyan and Red
Magenta and Green
Yellow and Blue

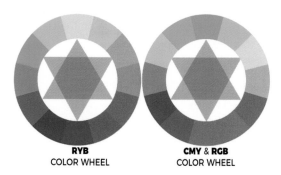

RYB
COLOR WHEEL

CMY & **RGB**
COLOR WHEEL

FIGURE 4-31

Again, think about coordinating your eyeshadows with your skin tone, rather than your eye color. For example, an orangey, golden color may complement your blue eyes nicely, but may not look as flattering on your skin if you have very pink undertones.

You may also prefer to use harmonious color combinations instead of contrasting complements. **Analogous colors** (colors found next to each other on the color wheel) can be used together to create a pleasing design. For example, blue-green, blue, and blue-violet are neighboring colors that create a smooth color transition when used together. There are many different combinations of analogous colors, so reference your color wheel for inspiration.

Eyeshadows can look very different applied to the skin compared to how than they appear in the packaging. Your end result will depend on the skin tone and the shadow's translucency.

IF YOU WANT A COLOR TO STAND OUT, TRY PRIMING THE LIDS WITH A LIGHTER COLOR. IF YOU'RE USING SATURATED, BRIGHT, OR EVEN NEON EYESHADOW, PRIMING THE LIDS WITH WHITE WILL HELP MAINTAIN THE INTENSITY.

Max Factor's Color Harmony Principle

In 1918, **Max Factor** stated that people with different hair colors looked best surrounded by different color palettes. He separated them by blondes, brunettes, "brownettes", and redheads, and named it the **Color Harmony Principle**. In 1935, he eventually redecorated the make-up rooms in his building to suit each palette: a blue room for blondes, a pink room for brunettes, a peach room for "brownettes", and a green room for redheads. These rooms have been authentically restored and are on view at the historic Max Factor Building in California.

Mascara

Mascara is typically used to make the eyelashes look thicker, longer, and defined, but it is also used to add color. If someone has blonde eyelashes, one of the quickest and most effective choices to bring out the eyes is to darken the lashes with mascara. This is because a darker color defines the whites of our eyes just like eyeliner does, so it works universally. For a softer look, try adding brown to the lashes. You can even try colored mascara, and use the same contrasting color principals that apply to choosing eyeliners and eyeshadows.

Eyebrows

When matching a natural brow color, start with a lighter shade than you think you'll need. You'll be surprised how much darker your brow color

appears once it's applied, and it is always much easier to darken a color than it is to lighten a color. It can also be helpful to mix more than one shade to mimic the variations found in hair color. For example, try a medium-dark brown brow color before using black on someone who has black hair.

FIGURE 4-32 BROW PRO PALETTE BY ANASTASIA BEVERLY HILLS.

Don't necessarily assume you should choose red, either, when working with red brows. People with red hair and fair skin often have pink undertones, which can make colors appear redder than they do in the packaging. Red eyebrows can make even the coolest ashy-browns appear very warm, so experiment first with a cool blonde or taupe color. If you need to darken or add warmth to the brows, you should do it slowly and only as needed.

Later, you may decide to make bolder choices for a specific look, but it's important to know how to naturally enhance a brow first.

Blush

Adding blush to the cheeks gives a person a flush of color, helping them look full of life. Blush mimics the blood flow to the cheeks that is visible in a healthy person.

Again, for a natural look, choose a blush that is the same color temperature and similar value as the person's skin tone. Look where the person is naturally flushed and try to replicate the color. You can even use less foundation on the cheeks so that the natural blush is exposed.

FIGURE 4-33

If you have *Light-to-Medium* skin that is **cool-toned**, try using **cool pinks**, **cool reds**, **mauves**, **rose**, and **berry** colors.

COOL

FIGURE 4-34

82

If you have *Light-to-Medium* **skin that is warm-toned**, try **warm pinks**, **warm reds**, **corals**, **peaches**, and **coppery-reds**.

If you have *Light-to-Medium* **skin with neutral undertones (including olive tones)** you can experiment with both cool and warm blushes. Typically, **peaches and peachy-pinks**, **corals**, **apricots**, **bronzy-reds**, **and rose** colors are flattering.

INTENSE

FIGURE 4-35

For **dark skin**, try an intense (saturated) color. A dull or neutral blush may appear grey or ashy when applied to dark skin. A color of higher intensity can naturally brighten the face, even though the color may not appear natural in the packaging.

If you have *Dark-to-Very Dark* **skin that is warm-toned**, try using **bronzes**, **cinnamons**, **warm reds**, **burnt oranges or rusts**, **bright oranges**, and **bright corals**.

If you have *Dark-to-Very Dark* **skin that is cool-toned**, try using **dark berries**, **crimsons**, **plums**, **fuchsias**, **magentas**, and **purples**.

Make-up containing a higher concentration of pigment will appear more opaque on the skin, and make-up with less pigment will be more translucent. The result of the same blush can also vary drastically depending on the color of the skin on which it is applied to and how pigmented the blush is.

Bronzer
If selecting a **bronzer**, pay attention to the color temperature of the person's skin. Bronzers are intended to warm your complexion. Try to avoid colors that are too warm because they could result in adding an orange cast.

BRONZERS

FIGURE 4-36

Cooler bronzers can look great on lighter skin and don't look as artificial.

For olive and darker skin, try honey colors, bronzes, and coppers.

Make sure your bronzer is not too dark because this can make the face appear "dirty". Usually, using one shade darker than the skin tone is safe.

Artificial Tans
Many sunless tanning products, including spray tans, use an ingredient called Dihydroxyacetone, or DHA. DHA does not stain the skin. It actually reacts with the cells in the top layer of the skin resulting in a brown pigment. This is similar to the way that melanin is produced during sun exposure, and also explains why it doesn't wash off. Using too much, or an uneven application, can result in an unwanted fake orange color.

There are also fake tanning solutions that temporarily tint the skin and wash off. Be careful

with your color choices, and remember that you are trying to replicate the color of melanin in the skin. If your skin is light and you use too much tinting product, it can also quickly appear orange. Many solutions contain blue or olive green pigments which aid in canceling out the orange cast.

Lips

If I had to teach someone just one thing about lip color it would be this: Find a lipstick that looks good on your face when you are wearing absolutely no make-up.

—Bobbi Brown

There are no real rules to your lipstick choices, but if you want a natural result, there are a few things to consider.

For a "no make-up" lip color, try to replicate the actual coloring visible on a person's lips, and even them out. You can even choose to match the color on the inside of the lips. To be subtle, keep the blush and lipstick similar color temperatures. Deeper skin tones tend to look natural when the lipstick is the same value as the skin, or darker.

At this point, you're most likely noticing a pattern when adding color for a natural look: If the skin's color temperature is warm, try a warmer color. Choose cooler colors for cool tones.

Color temperature is especially apparent when selecting bright reds. **Bluer reds**, **fuchsias**, and **cool pinks** flatter **cool tones**. **Peaches**, **corals**, and **orange-based reds** tend to look great on **warmer tones**. If you're having a difficult time choosing a color that stands out on dark skin, try an intense color with high pigmentation. You may notice that the same lipstick will look different on two separate people if they have different skin tones. Don't always assume that if a color looks good on someone else it will look good on you, too.

Lipsticks come in different textures and opacities, so it's important to be aware of what you're

WARM

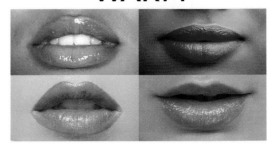

COOL

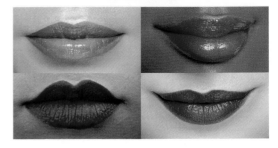

FIGURE 4-37 ORIGINAL IMAGES BY PROTASOV AN, KOSIM SHUKUROV, SEPRIMOR, ANDER5, MALYUGIN, LUBA V NEL, ANDRIY PETRYNA/©SHUTTERSTOCK. com. Edited by author.

FIGURE 4-38 LIP PALETTE BY ANASTASIA BEVERLY HILLS FEATURING THE PRIMARY COLORS FOR CUSTOM MIXING.

purchasing in order to obtain the desired effect. Lipsticks can be completely opaque, a sheer wash, or a transparent stain. Lipsticks can also contain light reflecting additives for a shimmery, glittery, or frosted effect. The **binder** that is used to create the lipstick will also

MIXING LIP COLOR

FIGURE 4-39

If you love how a color shows up on your skin, then use it regardless if it breaks every rule of harmonious color combinations. Make-up is a form of art, and art is about creative freedom and exploring new ideas. Before painting abstractly and pioneering the Cubism movement, **Pablo Picasso** first trained as a traditional painter and sculptor and was very skilled at painting realistic portraits. He also chose to creatively break the rules, but only after properly learning them first. Don't be afraid to try something new.

determine if it is matte, glossy, or somewhere in between.

Pictured is a lip palette by Anastasia Beverly Hills (Figure 4.38) that includes black, white, and the three primary colors. These colors allow you to adjust your lipsticks and custom blend shades, using the principals of color theory. Using palettes like this one means you can mix countless colors, which allows you to carry less individual products in your make-up kit.

Notice in the chart how the colors change when combined. See if you can determine what ratio of each color was used to achieve the end result, or try mixing these colors yourself.

MAKE-UP DESIGN

Breaking the Rules

Hopefully, now you have an understanding as to why certain colors flatter specific people.

Things to Consider

When planning a make-up look, it may be helpful to start your design by basing it off of one of these four combinations:

1. Light Eye and Light Lip
2. Light Eye and Dark Lip
3. Dark Eye and Light Lip
4. Dark Eye and Dark Lip

Keep in mind there's no right or wrong method for creating a look. You may prefer to base your design on specific colors instead.

You can also refer to the color schemes found in Chapter 1 (on page 10–11). You could select a **monochromatic scheme**, an **analogous scheme**, a **triadic scheme**, a **split-complementary scheme**, a **tetradic scheme**, a **square color scheme**, or even an **achromatic scheme**. Using one of these

schemes may help you narrow down your options during the design process.

A common error is choosing eye, cheek, and lip colors to coordinate with one's wardrobe. While this may be necessary for a specific character design, the results aren't typically flattering, and should only be considered if clearly required.

As a makeup artist, I've had to teach myself the endless variations possible with color. I've also learned how differently color affects each face I approach. The more I learn about different skin tones, bone structures, and even personalities, the better my work becomes. Be more open-minded yourself when it comes to using color.

—Kevyn Aucoin (*Face Forward*)

5

APPLYING COLOR THEORY TO SPECIAL EFFECTS MAKE-UP

COLORS IN THE BODY

As special effects make-up artists, we're often given the task of creating a convincing illusion. Whether you're mimicking a simple black eye or fabricating a complex sea monster, it's important to research relative things in nature in order to achieve a believable make-up design. Researching nature can also be a great way to draw inspiration during the preparation process.

One of the more common requests for television and film is to create simple cuts, bruises, and wounds. It's important to understand what these injuries actually look like before attempting to produce them. Reference photos and thorough research are necessary if your goal is realism.

The Circulatory System

When blood pumps from your heart, it moves through the three types of blood vessels: **arteries**, **veins**, and **capillaries**.

Blood

The red hue in our blood results from the mixture of iron and oxygen. **The more oxygen that is present in blood, the brighter the red**. Blood makes its journey by travelling from the heart through arteries, and then moves back toward the heart through the veins.

Arterial blood contains more oxygen because it has travelled through the lungs after leaving the heart. By the time the blood reaches the **veins**, it contains less oxygen. Therefore, the arterial blood is brighter than the deeper-colored blood that flows through the veins.

However, this doesn't explain why we see veins as blue or blue-green. Veins can only be seen through the skin, and the individual wavelengths of blue and red light penetrate the skin differently. **The thicker areas of skin only allow blue wavelengths to pass through, so we perceive veins as blue when the wavelengths are reflected back to our eyes**. This explains why veins seem to vary in color, depending on the individual's undertone. For example, the blue wavelength underneath a yellow undertone would give the appearance of blue-green veins. This also explains why people have **blue discoloration** under their eyes. The skin is much thinner in the area surrounding the eyes (about 1/4 the thickness of the rest of your body), which allows more light to pass through, causing discoloration and blood vessels to be more visible.

Arterial Blood—Brighter red, more oxygen (moves from the heart)
Venous Blood—Darker red, less oxygen (moves to the heart, closer to the skin)

Blood moves from the arteries and flows to the **capillaries**, which distribute oxygen to the different tissues.

ARTERY
Carries blood from the heart

VEIN
Carries blood back toward the heart

CAPILLARY NETWORK

FIGURE 5-1 Original Image by ALEXILUSMEDICA/©SHUTTERSTOCK.com. Edited by author.

> OUR LIPS AND CHEEKS APPEAR REDDER THAN OTHER PARTS OF OUR FACE, BECAUSE THEY ARE FULL OF CAPILLARIES.

When blood leaves the body, it begins to dry and release all of its oxygen, which causes it to become an even darker brown-red. Many times, if a character is wounded in a story, you may see

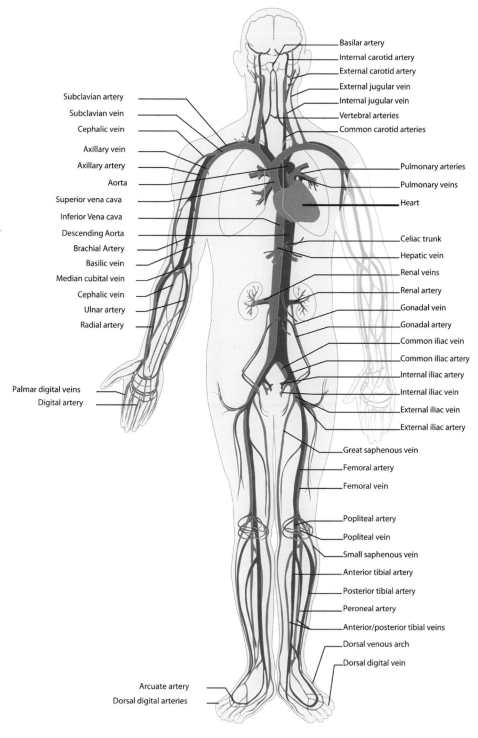

Basilar artery
Internal carotid artery
External carotid artery
External jugular vein
Internal jugular vein
Vertebral arteries
Common carotid arteries

Subclavian artery
Subclavian vein
Cephalic vein
Axillary vein
Axillary artery
Aorta
Superior vena cava
Inferior Vena cava
Descending Aorta
Brachial Artery
Basilic vein
Median cubital vein
Cephalic vein
Ulnar artery
Radial artery

Pulmonary arteries
Pulmonary veins
Heart
Celiac trunk
Hepatic vein
Renal veins
Renal artery
Gonadal vein
Gonadal artery
Common iliac vein
Common iliac artery
Internal iliac artery
Internal iliac vein
External iliac vein
External iliac artery

Palmar digital veins
Digital artery

Great saphenous vein
Femoral artery
Femoral vein

Popliteal artery
Popliteal vein
Small saphenous vein
Anterior tibial artery
Posterior tibial artery
Peroneal artery
Anterior/posterior tibial veins
Dorsal venous arch
Dorsal digital vein

Arcuate artery
Dorsal digital arteries

FIGURE 5-2 THE CIRCULATORY SYSTEM.

different stages of healing. It's important to observe how colors change over time as wounds heal in order to replicate them accurately and consistently.

Also, notice how the area around an injury can become red, due to irritation and increased blood flow to the wound. Recreating this irritation can help authenticate your effect. Look at the person's natural cheek coloring or another flushed area of the skin. Try to match this color and use it to surround any areas of damaged skin.

FIGURE 5-3 Photography by ThamKC, schankz, Pakenee Kittipinyowat/©Shutterstock.com. Edited by author.

FIGURE 5-5 BLOOD PASTES IN A DRIED BROWN-RED, YELLOW-RED, AND BRIGHT RED. *Fleet Street Blood Pastes.* Owned, developed and maintained by Kenny Myers/CMI, Manufactured by PPI.

FIGURE 5-4 Original Image by Saivann, ratsadapong rittinone/©Shutterstock.com. Edited by author.

When shopping for fake blood, you'll notice that it comes in a variety of colors ranging from bright reds to dark chocolate colors. Some appear more orange, and some are more pink. Be sure to consider where in the body the blood is coming from, as well as the lighting and setting of the story. A bright red blood may show up well in a very dimly lit set, but appear too bright and fake in the daylight.

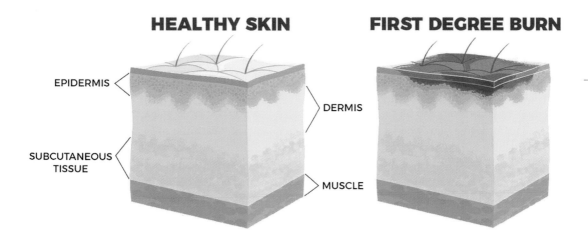

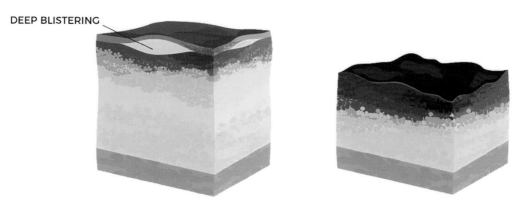

Burns

Skin tissue can be damaged from different types of burns, for example, fire, hot liquids, chemical burns, and electrical burns. The skin can turn red, pink, and yellow, and blister or peel when it's healing. Severe burns can even turn the skin black or white. It's important to find reference pictures of the severity and type of burn you are trying to recreate before you start your make-up application.

First-Degree Burn / Superficial Burn—Reddened skin without blistering.

Second-Degree Burn / Partial Thickness Burn—Reddened skin with blisters.

Third-Degree Burn / Full Thickness Burn—Skin becomes white and waxy. Skin may be charred dark brown or black. A full thickness burn can also be categorized as a fourth-degree burn when it affects the muscles and even bones.

When recreating burns with make-up, a good place to start is to mix an intense bright red with the person's natural blush color. Usually, the result is similar to the color that is present at the site of the burn. Then, you can adjust your mixture by adding deeper blood reds and charred colors where appropriate.

Sunburn

A **sunburn** is a type of radiation burn that can occur when a person is overly exposed to ultraviolet rays from the sun. The skin can turn very red and even blister, depending on the skin type and the amount of sun exposure. The blood flow is increased to heal the affected area, which explains the warmth and redness that occurs.

Sometimes adding a touch of red make-up on the nose, cheeks, and top of the forehead can be effective if you're recreating the appearance that someone has been in the sun all day.

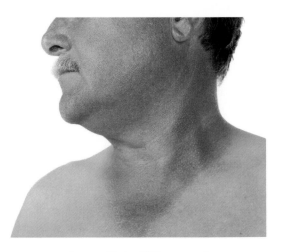

FIGURE 5-8 Suzanne Tucker/©Shutterstock.com.

Bruises

When you're injured and a **contusion** (bruise) appears, it means the small **capillaries** have burst, and blood becomes trapped under the skin. As the wound heals and the blood breaks down, the colors change. This explains why bruises appear in so many different colors.

Bruises can form quickly when the injuries are close to the skin (typically with minor injuries), because the blood travels faster to the surface. These colors can even be noticeable within a few minutes.

When the injury is more **substantial** (like a sprained ankle), the bleeding is much deeper and takes longer to rise to the skin's surface. Sometimes, the color won't be very apparent for days.

Bruises go through a progression of colors as they heal. When working in television or film, many times a character will develop a black eye or a bruise that heals throughout the story line. It's important to know how these colors may shift so that your effect is believable once the scenes are edited together.

FIGURE 5-9 Lukiyanova Natalia frenta/©Shutterstock.com.

FIGURE 5-10 Patcharapa/©Shutterstock.com.

HEMOGLOBIN→BILIVERDIN→BILIRUBIN

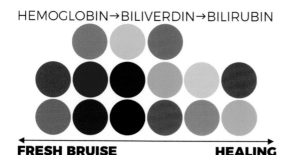

FRESH BRUISE **HEALING**

FIGURE 5-11

Bright Red

Bruises usually start as red spots, due to the fresh blood that has risen to the surface of the skin. The blood is still full of oxygen, which makes it appear brighter.

Dark Red

When the blood in a bruise begins to lose oxygen, it darkens. The iron in the blood breaks the bruise down, creating dark reds and darker purples.

Dark Purple/Blue

When there is little to no oxygen left in the blood, the bruise becomes dark purple or blue. Bruises also appear darkest when they are deep under the skin. They can even look black where the purple is most concentrated.

95

Green

Green appears around the bruise when the **hemoglobin** (protein in the blood which transports oxygen) begins to break down. During this process, **biliverdin** (a bile pigment) is formed, which is green in color.

Yellow/Brown

Yellow and brown appear around a bruise when **bilirubin** is present. Bilirubin is a yellow-brown substance, and it is created as red blood cells are broken down while the body is clearing away blood from a bruise. Bilirubin is usually visible during a bruise's final healing stage.

A **black eye** is a form of a contusion. The blood travels and pools around the eye and is more apparent because the skin is much thinner. A black eye doesn't necessarily form because of trauma directly to the eye. Many times the blood can pool underneath the eyes when an injury has occurred to a surrounding area or to the nose.

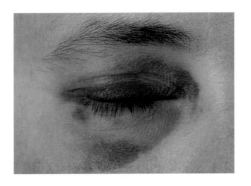

When choosing the correct colors to replicate your bruising effect, make sure to test them on the skin. Often, make-up will appear much darker in the container than it does on the skin, and can vary depending on the skin tone. Pay close attention to reference photos and color patterns before beginning your make-up application. Try to break up your colors (don't use solid strokes), so the camera reads them more naturally. Also, be selective with your reference photos, because sometimes even a real photo of a solid black eye can look fake when replicated if the color pattern is too solid or appears in a distracting shape.

Scars

Most likely you've had a scar, and you may have noticed the progression of color changes through the stages of healing. Typically, when the skin is broken, blood vessels are damaged, and the initial color of the scar becomes red or red-purple due to increased blood flow to the area.

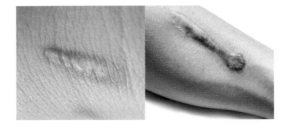

Over time, the darker reds will fade and can appear more pink. Sometimes, the **melanin** producing melanocyte cells (pigment-producing cells) are damaged, so the scar never returns to the natural color of the skin. This is why many scars can appear lighter or white over time. Sometimes too much melanin can be produced during the healing stage, which results in **hyperpigmentation** and darker brown areas. The skin repairs itself quickly, but scars may fade and change in color or texture for one or two years as they heal. Sun exposure can also affect the color of a scar while it's healing, because it can prevent fading.

Scars come in a variety of colors, shapes, and sizes, because skin heals differently depending

FIGURE 5-13 SWOLLEN BLACK EYE MAKE-UP ON ACTOR DANIEL HENSHALL. Make-up and prosthetics by the author.

96

on the trauma and the individual. Again, be sure to carefully study your reference photos before deciding which colors to paint a prosthetic scar.

Cold and Frostbite

When you're exposed to extremely cold temperatures, blood vessels in your skin constrict, which can cause your lips to appear blue. Damage to the skin can even occur if it is exposed to freezing temperatures or ice. If the skin tissue freezes, the blood flow to the affected area is reduced. This is called **frostbite**. It can occur anywhere on the body, but it's most common in the outer extremities because they are more exposed to the cold.

> **First-degree frostbite** will mainly turn red (and sometimes yellow) and is not very severe.
> **Second-degree frostbite** will result in dark blisters and leathery skin.

In more extreme cases, **third-degree** and **fourth-degree frostbite** can form, which is when the freezing occurs below the skin. Blisters can turn black and deep red, and may even become gangrenous. Typically, the outer extremities (nose, tips of toes and the fingers) will turn black first, and the skin can peel and appear rubbery. Again, it is very important to utilize reference photos, and pay close attention to the colors and patterns that are visible.

Sickness and Death

You may have noticed a loss of color in your face when you're sick. Complexion color can be a good indicator whether or not you're healthy. That's because there is reduced blood flow and oxygen to the face when you're unhealthy. Blood moves to more vital areas like the organs, and away from extremities. Blood can also move to

the organs when dealing with stress or anxiety or when regulating the body's temperature, which also can cause paleness.

When someone dies, blood is no longer circulating through the body, which results in a much more noticeable loss of color (especially in the face). If you're creating a death make-up, or a very ill look, one of the quickest and most effective techniques is to add a pale flesh tone to the lips and to remove any redness from the face.

Accentuating **dark circles** under the eyes is another way of convincing the audience that someone is sick. Purples and reds can be effective, but be careful not to make them look like black eyes. Thinning out the product is a good way to keep the effect subtle.

Jaundice is a type of sickness that can occur which creates a yellowy skin color. This happens when the liver doesn't properly break down **bilirubin** (a yellow pigment found naturally in mucus and skin), so the color becomes noticeable. Jaundice is common in babies whose livers are still developing.

Dirt and Mud

If a character needs to be dirty, be aware that there is not one universal color of dirt. Don't select the first brown you have available without assessing the situation. You should always first determine where the dirt originated. For example, a script could describe a character as being "dirty", but you would never want to send an actor to set wearing red clay dirt make-up, only to discover later that the set is filled with a white, chalky dust. Try to visit the set in advance, or speak with someone about the type of dirt or mud that is present so you're prepared.

Expect to find a range of light to dark browns, grey and/or black soot, chalky whites, earthy reds, yellows, and even green dirt.

FIGURE 5-16 ALCOHOL-BASED PALETTE IN 10 DIRT COLORS. *Skin Illustrator Grunge Palette.* Owned, developed and maintained by Kenny Myers/CMI, Manufactured by PPI.

Tattoos

Color is very important when creating a fake tattoo. When a real tattoo is made, ink is deposited into the skin's **dermis** (second layer of the skin), and is trapped underneath the **epidermis** (the top layer of skin). No ink is present in the epidermis, so the tattoo that we see is actually visible through a translucent layer of skin. This is why mimicking a tattoo by using a dark black or intense color of make-up can instantly appear fake. It will look more realistic if you select colors that are lower in intensity

and in value, so they won't appear to sit on top of the skin. If you're creating the tattoo on a computer, be sure to tone down the overall saturation. You may also want to add a thin layer of foundation or a colored powder on top of the tattoo, so that it appears as if it's below the skin's surface.

Also, keep in mind that tattoos do not always retain their color over time. Pigments found in tattoo ink are much more stable today, but they can still fade and change colors. The older the tattoo, the more it will fade. Black is typically the most noticeable color that changes, because it can turn blue-black or even blue-green. Therefore, you should keep in mind how long a character is

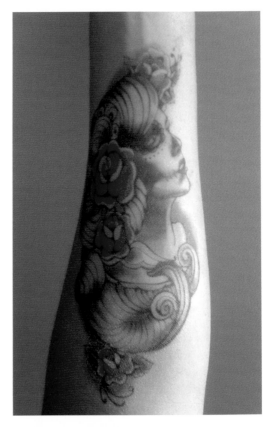

FIGURE 5-17 TATTOO DESIGNED BY HAND, DIGITALLY COLORED, AND PRINTED ON TRANSFER PAPER. Designed and applied by author.

FIGURE 5-18 ALCOHOL-BASED TATTOO COLORS IN A FADED GREY-BLUE AND BLUE-GREEN. *Skin Illustrator Tattoo Classics.* Owned, developed and maintained by Kenny Myers/CMI, Manufactured by PPI.

supposed to have had a tattoo when designing it. If the character has an old tattoo that was supposed to be poorly done, you'll likely want to fade it more dramatically to a grey blue-green. A new and professionally applied tattoo should appear more saturated, and better-quality inks are more stable. If the character has just been given the tattoo within the past few days, remember that the body sends blood to an area that is inflamed. Adding a wash of red to simulate the irritation around a new tattoo can help convince the viewer that it is real.

As always, reference photos are extremely helpful for creating a realistic application, but try to look closely at a tattoo in person to compare how colors read through the layers of the skin.

Teeth

A very effective way to change a character's look is to change the color of their teeth. Adding brown or yellow stains is a quick way to give an impression of poor hygiene. Black can even be added to give the illusion that teeth are broken or missing. This is because the black colorant gives the appearance that the tooth is not present to reflect the light, which creates the illusion of a void. When creating a fictional character, adding more unusual colors like green or blue to the teeth can also be helpful.

PAINTING PROSTHETIC APPLIANCES

Painting prosthetic appliances or pieces like bald caps can be challenging. If you want the prosthetic to blend seamlessly to the skin, then you'll need to be selective about color for a convincing match. If you simply match the color of the skin and paint the prosthetic a solid color, it will be very apparent that the added piece is not real. Think about layering colors the same way that they are scattered through transparent layers of the skin.

A portrait painter has to consider this, too, when starting with a white canvas. The painter can't simply paint a face a solid skin color and expect it to be interpreted as realistic skin. Colors of light and shadow must be carefully observed, and the paint must be layered to imitate the complexity and texture of skin. We do not just see the surface color of skin, but we also see blood through capillaries, blue or green veins, and pigmentation like freckles. It's impossible to account for all of these layers by using only a single, solid base color.

It's also important to use color theory when you need to neutralize or to add specific colors. For instance, if your prosthetic looks too orange, you can apply a layer of blue over the top to cancel out the orange. Again, don't be afraid to reference your color wheel.

Stippling

When creating effects with make-up, sometimes layering color products can result in a "muddy" mixture where colors have been unintentionally blended. You may have envisioned for the paint on your prosthetic to have red in one spot and green in another, but you accidentally overworked both colors so they combined and formed a dull grey-brown. Another problem you could face is discovering that your prosthetic doesn't seem to have any depth on camera, because you've painted it a solid color.

Think about the **Pointillist** painters (mentioned in Chapter 1) who painted with tiny dots of color.

This technique allows the eye to **optically mix** the colors (as opposed to physically mixing them together), which creates rich blends and adds dimension. **Georges Seurat**'s painting "Circus Sideshow (Parade de cirque)" is a great example of how stippling can be effective. When you're standing far away, the painting appears full of neutral colors. On closer inspection, you'll see the painting is made of intense colors like oranges, blues, and greens.

Consider this technique while painting prosthetics. If you're painting something you intend be a neutral grey, you may want to try alternating dull blue and orange patterns, rather than selecting a grey paint. The camera typically blends these colors the same way our eye optically mixes them. This will give your prosthetics a layered look rather than a flat

opaque result. It will help mimic the complexity that is apparent in skin and other textures that you may be trying to match.

One method of keeping colors separate is called **stippling**. Using a sponge with a pattern, you can press colors directly onto the skin or the prosthetic in layers. This keeps the colors from blending together and provides a textured look.

You can buy stipple sponges or natural sea sponges that come in many different patterns. Make sure to cut off any hard edges and round out your sponge so that you don't end up with unwanted straight lines. Some brushes that have spaced-out bristles can be great for stippling, too. You can even cut up a make-up wedge to create particular patterns and use it as a stamp. A finer

FIGURE 5-19 "CIRCUS SIDESHOW" (PARADE DE CIRQUE) BY GEORGES SEURAT. Oil on canvas. Paris 1859–1891. The Metropolitan Museum of Art, New York.

FIGURE 5-20 DETAIL OF "CIRCUS SIDESHOW" (PARADE DE CIRQUE) BY GEORGES SEURAT. Oil on canvas. Paris, 1859–1891. The Metropolitan Museum of Art, New York.

FIGURE 5-21 BLACK STIPPLE SPONGE, NATURAL SEA SPONGE, ORANGE RUBBER STIPPLE SPONGE, AND A BRUSH FOR STIPPLING.

texture can be created by flicking or spattering colors off a stiff brush for a sprayed effect. Don't be afraid to experiment with different tools and textures. Squint your eyes, step backwards, or look at your work in a mirror. This will help you estimate how your make-up may read on camera.

Also, consider stippling instead of painting when you quickly need to tone down a color that is

too strong. You may arrive on set and realize certain lighting negatively affects your paint job. Then, you might want to change the overall color but without affecting the texture and detail that you have already created. Stippling a thin and translucent layer over your work is a quick and effective way to deal with a colorcast, while preserving your paint layers. You also may find it a helpful skill if you need to reduce contrast when highlights or shadows are too strong.

Stippling is a great way to shift color from a person's skin to a **prosthetic** or a **bald cap**. Think about how layered, detailed, and textured the skin is, and how different a smooth rubber or vinyl bald cap is. Stippling and stamping texture to transition the two into each other can help give the appearance that they blend seamlessly.

Stippling can also be helpful when creating new textures, like scrapes and bruises. Fine sponges can be used to mimic **broken capillaries** and tiny abrasions to the skin.

FIGURE 5-22 SCRAPES CREATED WITH A BLACK STIPPLE SPONGE AND SKIN ILLUSTRATOR ALCOHOL-BASED PAINT.

If you're creating a **beard shadow** on a freshly shaven face, stippling can also be very effective. As mentioned in Chapter 4, you may want to start with a low intensity blue wash over the face where the beard shadow starts. Then, stipple on a darker brown to create a texture that looks like hair follicles protruding through the skin. The stipple sponge can help create tiny dots that would be incredibly time-consuming to add with a brush.

FIGURE 5-23 BEARD STUBBLE CREATED WITH A BLACK STIPPLE SPONGE.

If you're matching a natural skin color, hopefully your prosthetics have already been colored to resemble your subject's skin tone. Many times, this isn't the case. If you're starting with a white bald cap or a prosthetic that's the wrong color, you may find it helpful to start by painting it a base color that matches the skin. Next, you can layer a red pigment that matches the person's natural flush. It helps to stipple this and keep a pattern which allows your base color to show through underneath. Next, think about the blue veins that are noticeable in many people's skin. You may want to overlap patterns of a low intensity blue, too. Blue can also help fade any unnatural colors like bright oranges. At this point, step back and look at your overall color. You may choose to add warmth by adding a wash of yellow or olive tone. It's important to remember the **complementary color** pairs, so that you can

balance or neutralize colors accordingly. Then you can proceed with thin washes and stippled colors to mimic veins, freckles, and capillaries.

There is no right or wrong way to add color, but beginning with reds can be an effective way to quickly bring life into the prosthetic. Pay close attention to where the red may be more concentrated; for example, you'll see that the hands have more red on the knuckles and fingertips.

Intrinsic Color

You may find yourself not only painting prosthetics, but fabricating them, as well. When you're working with a clear or translucent material (like silicone or Pros-Aide prosthetic transfer material), you can color your prosthetics intrinsically, which basically means to trap a color inside the material while it's being created. **Intrinsic** is defined as "belonging to or lying within a given part".

Depending on the amount of color you add, your piece can vary in opacity or translucency. Liquid tints can dramatically color your prosthetics and make them opaque. **Flocking** can also be used to create a natural and subtle color effect, while allowing the material to hold on to its translucent properties. Flocking is made of tiny colored fibers and it can be suspended into the material intrinsically while it is being fabricated. For example, flocking can be stirred into silicone before it sets, so that the fibers become trapped when the silicone hardens. This helps mimic the different colors we perceive throughout the layers of skin, and our eye optically mixes them together. Opaque prosthetic materials (like foam rubber latex) can't be fabricated with the same type of intrinsic color depth, so the textures and color layers must be added on top of the prosthetic, instead.

It can be very helpful to suspend colors like red and blue flocking, because they can appear trapped under the skin the same way blood vessels and veins are. If the person you're

FIGURE 5-25 FLOCKING FIBERS SUSPENDED IN SILICONE.

matching is more olive-skinned, you may want to add blue-greens instead of only blue. Look closely at the two swatches of silicone in the photo. You can see how the individual blue and red fibers add to the overall coloring and texture.

In the next photo, you can see the unpainted silicone belly (left) that is colored intrinsically with flesh tones, reds, and blues. The next photo (right) shows where color is added and painted on top of the same belly in reds, blues, yellows, and browns.

When to Add Black
As mentioned in Chapter 1, changing a color by adding black will make the color appear dull. Darker and less saturated colors tend to make objects appear as if they are farther back, so you need to be selective when you choose to use black. However, using black can be a helpful tool if you're trying to make an area appear as if it is receding. For example, if you're painting a bullet-hole prosthetic, placing black in the hole can give the illusion on-camera that it goes much deeper than it actually does, because it appears there is no light present. Black can also be a great choice in bold designs, because it can accent lighter-valued colors, like a bright yellow.

103

FIGURE 5-26 AN UNPAINTED SILICONE PREGNANT BELLY (LEFT), PAINTED SILICONE PREGNANT BELLY (RIGHT). Fabricated and painted by the author.

COLOR INSPIRATION FOR CHARACTER DESIGN

Psychological Effects of Color
When creating an expressive type of make-up design (e.g., fashion, body painting), you may want to consider the psychological effects that people naturally feel from looking at certain colors.

Colors can evoke emotions, and trigger certain moods. **Cool colors** are associated with relaxation and tranquility and are linked to water and the sky. **Warm colors** are linked to fire and the sun and are related to energy and intensity.

The feelings that evolve from seeing certain colors can be so effective that many businesses take these

RED - energy, passion, love, strength, power, intensity, aggression, violence

PINK - sensitivity, delicateness, love, sweetness

ORANGE - energy, creativity, friendliness, happiness, excitement, courage

YELLOW - cheerfulness, positivity, uplifting, happiness, optimism, joy

GREEN - hope, nature, harmony, tranquility, growth, freshness, life, envy

TURQUOISE - peace, balance, creativity, calmness, healing, uplifting

BLUE - calmness, trust, comfort, relaxation, loyalty, wisdom, tranquility, coldness

PURPLE - spirituality, serenity, fantasy, royalty, mystery, luxury, calmness, peace

BROWN - conservativeness, earthiness, reliability

GREY - balance, practicality, neutrality, dullness

WHITE - cleanliness, purity, peacefulness, innocence, virtuousness

BLACK - drama, tradition, formality, intelligence, power

FIGURE 5-27

connections into consideration when branding and marketing their products and companies.

Listed above are common emotional associations that are related to individual colors. Keep in mind that some colors can have multiple meanings, depending on how they are used.

Inspiration: Colors in Nature

When painting appliances or creating characters, your task won't always be matching a human flesh tone. When you're creating a fantasy make-up or a character that doesn't have a typical skin color, it can be very helpful to draw your inspiration from nature. For example, if you need to create a green creature, pull photos of green reptiles, birds, plants, and even food. You'll be surprised how many colors are layered and what patterns you may find when you are carefully observing them.

You may also want to reference the various color schemes (found in Chapter 1 on page 10–11) when creating make-up designs for characters. For example, you could choose a scheme like a split-complementary color combination on which to base your design. Laying out color patterns ahead of time can help you prepare for a successful application.

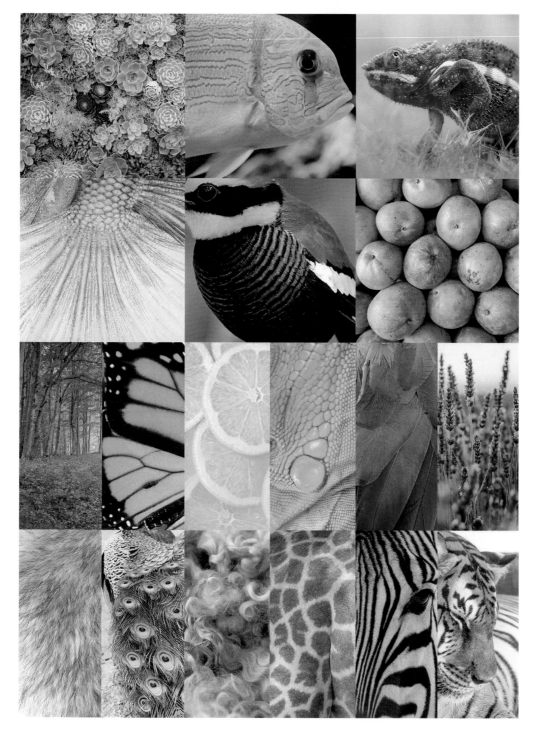

FIGURE 5-28 Photography by YIUCHEUNG, Giancarlo Liguori, Arif Supriyadi, Napat, BOONCHUAY PROMJIAM, Fotoluminate LLC, Andrew Mayovskyy, Dave Nelson, Ollinka, Nuttapong Jeenpadipat, Narupon Nimpaiboon, Anton Gvozdikov, VicW, Lena Lir, Anna Hoychuk, Wanida_Sri, SWP222, Petrenko, Andriy/©Shutterstock.com. Edited by author.

6

HOW LIGHTING
AFFECTS COLOR

LIGHTING YOUR WORKSPACE

"To be a painter, one must work with rays of light."
—Edvard Munch (1863–1944)

The only reason we see color is due to the presence of light, so it's important to understand the power that light has to affect your make-up choices. You may be equipped with the best tools, high-end make-up, and an eye for color, but if you can't see what you're working on, then you may struggle to select appropriate colors (like the correct foundation). Putting yourself in the best possible lighting situation when applying make-up can help you avoid major adjustments later. Most likely, you'll find yourself more confident with your color choices, which can help you work faster and more efficiently.

108

FIGURE 6-1 Volodymyr Burdiak/©Shutterstock.com.

Many times, the lighting in the room where you apply make-up is very different from the lighting where the subject will be featured. It's important to familiarize yourself with how changes in lighting can affect your work, in order to avoid surprises once you see the final look on stage or on camera. Learning to adjust to circumstances, like shifts in lighting, is essential.

Natural Light

Natural light is the best lighting for applying make-up. The problem is that you can't always control it, and it's not always consistent. Changes occur during different times of the day, and

sometimes natural light can be too glaring, not bright enough, or uneven with heavy shadows. However, if you can catch it under the right conditions, natural light is ideal because the color temperature is balanced, and the light is bright enough to fully see your subject.

Another issue you may face is that natural lighting can be perfect in the morning and then unusable when you need it later in the day for touch-ups. That's why we need balanced make-up lights, so that we can be ready for applications throughout the day. If you're working in television and film, you'll often find that you begin work before the sun comes up, so the use of natural light won't even be an option.

If you are able to utilize the sunlight, start by turning the person to face the window or toward the source of the light in order to illuminate their face. Try to avoid shadows on the face caused by light beaming from different angles. Sometimes, a sheer white curtain placed over a window can help diffuse the light and reduce the glare. Also, be careful that the sun isn't shining directly into the person's eyes, and be courteous of the temperature, as well, because it's not going to be enjoyable for either of you if the person starts to perspire. If the direct sunlight is too intense, consider facing the person toward a white wall that reflects the light.

Color Temperature of Light

It's important to have your make-up area balanced and bright, so that you have every

FIGURE 6-2 WARM, NEUTRAL, AND COOL LIGHT.
Credit: gualtiero boffi/©Shutterstock.com.

advantage in making your work the best that it can be. Think about categorizing lighting the same way that we classify other colors in terms of **warm**, **neutral**, and **cool**. Ideally, you'll apply make-up in bright, clean, neutral light so that you can see your subject well and without color casts.

Typically, **warm light** is flattering on most people (think about candlelight or a sunset), but if your lighting is too warm while applying make-up, you may mistakenly make choices based on the lighting temperature instead of the person's actual coloring. Very warm light may remove the appearance of rosiness from the face (since yellow softens red). This can cause you to accidentally overcompensate by adding too much color, like blush.

It can also be problematic if the lighting is too cool. **Cool light** leans toward blue, which can make the skin look washed out. It's easy to overcompensate with make-up by adding too much color when the skin appears to be colorless.

Every light source gives off a natural color. Color temperature is measured by a unit called a **Kelvin** (represented by "K"). For example, candlelight is approximately 1,500K, daylight is around 5,600K, and a blue sky is roughly 10,000K.

KELVIN COLOR TEMPERATURE CHART

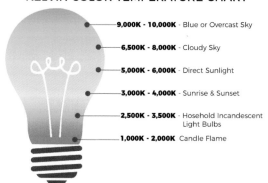

9,000K - 10,000K - Blue or Overcast Sky

6,500K - 8,000K - Cloudy Sky

5,000K - 6,000K - Direct Sunlight

3,000K - 4,000K - Sunrise & Sunset

2,500K - 3,500K - Hosehold Incandescent Light Bulbs

1,000K - 2,000K - Candle Flame

FIGURE 6-3

Our brains are able to understand an object's color by innately balancing any adjustments of light that we see. For example, we identify a white piece of paper as white even if it is

viewed under colored lighting. Just because our brains naturally understand this, a camera won't necessarily account for this properly without assistance. That's why it's important for a photographer or a cinematographer to control the temperature of the lights that are being used, as well as to **white balance** the camera (adjusting the color temperature in-camera to remove color casts to create a neutral white).

> *Whether you are sixteen or over sixty, remember, understatement is the rule of a fine makeup artist. Adjust your makeup to the light in which you wear it. Daylight reveals color; artificial light drains it.*
> —Helena Rubinstein (1870–1965)

Light Bulbs

Incandescent light bulbs are the original type of light bulbs. They work by heating up a piece of filament to a high temperature so that it gives off light. Incandescent bulbs provide warmer lights, which appear natural and flattering on the skin.

LEDs (Light Emitting Diode) and **CFL**s (Compact Florescent Light) are newer, energy-saving light bulbs that can be used in place of incandescent bulbs. Both types of bulbs are available in a range of different color temperatures, so be selective when purchasing bulbs. Some are warmer to mimic incandescent light, and some emit a cooler or bluer light. Both LED and CFLs have a version

FIGURE 6-4 LEFT TO RIGHT: INCANDESCENT BULB, CFL BULB, LED BULB. Credit: Chones/©Shutterstock.com

of **daylight bulbs**, which are intended to mimic the tone and color of daylight.

Color Rendering Index

The **Color Rendering Index** (CRI) is a measurement used to determine the color

accuracy of a light source. CRI is unrelated to color temperature. A source's projected light is measured on a scale from 1–100, and the rating is determined by how it compares to natural reference light that contains the full spectrum (like daylight). Any light source with a CRI of 85 or above is considered to be proficient at color rendering.

For example, a light source with a CRI of 98 that is close to 5,600 Kelvin would be a great choice for a make-up application because it would render color well and be daylight balanced.

Credit: Jesus Cervantes/©Shutterstock.com. Edited by author.

However, there is another factor to consider when determining the accuracy of a light source where the CRI number could be misleading. When a light source's CRI is compared to that of a reference light, it's tested based on how accurate 8 color samples appear. These samples are labeled R1–R8, and range from muted pinks, ochers, greens, blues, and lavenders. A light that renders these 8 colors well is rated with a high CRI. The problem is that there are additional color samples (R9–R14) that aren't factored into the CRI rating. The first of these additional test colors is R9, which is an intense prime red. When R9 is not included as part of a CRI rating, it leaves us unaware of how well a particular light source renders a strong red. If a light does not reveal reds accurately it can be incredibly problematic for a make-up application because reds are so prominent in the face and body. Therefore, choose a light source that has a high R9 rating and don't assume it is adequate based on the R1–R8 CRI test results alone.

Portable LED lights are a popular option for workspace lighting because they use less electricity and are long lasting and lightweight. Keep in mind that many inexpensive LEDs have poor R9 ratings, which means they may inaccurately represent any redness in the face or added colors like lipstick and blush.

Make-Up Rooms and Trailers

Most professional make-up rooms, dressing rooms, and make-up trailers are equipped with lighting that surrounds mirrors and hopefully evenly brightens the room without shadows. Many of these lights can even be adjusted from warm to cool. However, don't assume that the lights project a proper representation of the full color spectrum. You may need additional daylight balanced lights with high a CRI for the most accurate lighting possible.

It is helpful to use lights where the color temperature and brightness can be adjusted. This way, if you know how the set is lit, you can try to match the make-up room lighting before applying

make-up. This will help prevent major on-set make-up adjustments later. Always be prepared to alter the colors of your make-up. Even the slightest changes in lighting can affect your work, so be ready to make quick modifications on set.

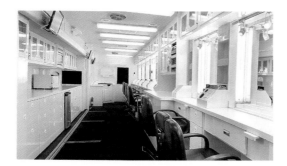

FIGURE 6-5 INTERIOR OF A MAKE-UP AND HAIR TRAILER. Credit: Photo courtesy of Star Waggons.

Try to look at the set or stage lighting in advance, so that you can estimate how the make-up will read. You'll want to be proactive by checking schedules and being aware of whether you're filming indoors or outdoors, as well as the time of day. Keep in mind that many times you won't have the opportunity to see the set, so if in doubt, apply make-up in bright, clean, and neutral light whenever possible.

Once you see the person on camera or onstage, expect to make some tweaks, so the make-up reads the way you envisioned it. When working in theater, you'll find the lighting design and contrast are typically much more severe, so be prepared for an extreme change from what you see in the dressing room. Boldly colored lighting can accentuate make-up, or make it completely disappear.

Sometimes you'll find yourself in locations lacking preferable lighting options, so you'll need to make the best out of what you're given. If your lighting situation is less than ideal, attempt to find a source of natural light. Don't hesitate to ask for additional lights, or to switch rooms if there's a better option available. People will often be accommodating, and respect that you're trying to do the job to the best of your ability.

Portable Lights

When working in locations unequipped with preferable lighting (like hotel rooms for bridal make-up), you may want to consider purchasing a portable lighting system to provide your client with the most accurate and even lighting available.

When using a portable make-up light, there are specifications you should consider. The light should be bright enough to see clearly, but it should also be diffused so that it is not too harsh on the skin or to the eyes. You should also make sure that the color temperature is as neutral as possible. **Be aware that all artificial lighting has limitations, and many lights do not project the full color spectrum, which can leave us with an inaccurate representation of color**.

When using a portable light, make sure it is daylight balanced, bright, projects far enough, and has a high CRI as well as a high R9 rating like "The Makeup Light" designed by Michael Astalos and Emmy-Award winning make-up artist Vivian Baker.

Caption: Photo Courtesy of The Makeup Light.

111

"After all, Makeup artistry is a visual art . . . and it requires light to be able to see. The quality of your light is relative to the quality of your work."

—Vivian Baker

If you're using portable lights or bulbs to illuminate the face, try to place the sources so that the lighting is above and around the face. Otherwise, you may have to deal with uneven shadows and possibly difficult lighting. This is why many personal make-up mirrors have a circle of light around the perimeter to help evenly illuminate the face.

Portable ring-shaped lights are also available, and can provide light from every side of the face when positioned so the circle of light surrounds it. These can be very useful for applying your own make-up or for photographing a face, but keep in mind ring lights may not be effective when applying make-up to someone else. Many of these portable lights do not project very far, and the circle of light needs to be positioned so that the face is in the center. This means that you may end up either blocking the light or blocking your own workspace when a ring light is positioned correctly onto someone else.

If you find that the lighting is not ideal when selecting colors (like foundations) for someone, don't be afraid to take the person outside for a better look under natural lighting. Most of the time they'll appreciate your attention to detail and accurate color matching.

COLORED LIGHTING

As mentioned in Chapter 1, objects reflect light waves back to our eyes, which is the reason we perceive specific colors. We identify an object's color based on the colored light wave that it reflects, while the remaining light waves that we can't see are absorbed. If the object absorbs all colors at once, then we recognize it as black. If it reflects all colors, we identify it as white. If it reflects all colors partially, but evenly, it appears grey.

Color mixing with light is very different from mixing color with paint or make-up.

FIGURE 6-6 Credit: Subbotina Anna/©Shutterstock.com.

Unlike pigments, colors of light actually brighten as they are mixed. Mixing all three primary colors of light (also known as the "**full spectrum**") results in white. When light is mixed, it is referred to as **additive** color mixing because wavelengths of light are added to each other. The opposite is **subtractive** mixing, which results in black when all wavelengths are subtracted. (Subtractive mixing is what we're accustomed to when using paint and make-up, and deals with the mixing of pigments.)

Not only are the primary colors of light different from our traditional pigment primaries, but the color wheel and complementary colors differ, too.

The **primary colors of light** are: **red**, **green**, and **blue**.

RED-GREEN-BLUE
Primary Colors of Light

FIGURE 6-7

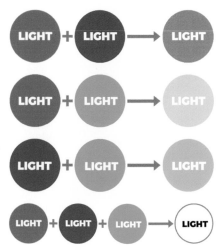

MIXING **R-G-B** SECONDARY COLORS

Red Light + Green Light = Yellow Light

Green Light + Blue Light = Cyan Light

Red Light + Blue Light = Magenta Light

Red Light + **Green Light** + **Blue Light** = **White Light** (also known as the full spectrum)

FIGURE 6-8

The **spectral color wheel** has a different order of colors from the traditional pigment-based color wheel. The complementary color

pairs are still located across from one another, but take note of the differences when dealing with colored light. (For example, red and green are complements when using paint, and red and cyan are complements when using light.) Complementary colors of light cancel out each other, resulting in white. You should also consider using these complementary color combinations for contrast in your make-up designs in addition to the traditional pairs that you're accustomed to.

The **complementary colors of light** are:

Red and Cyan
Green and Magenta
Blue and Yellow

Take a look at the photo where two lights are shining on a woman, one from each side. If a

FIGURE 6-9 BLUE LIGHT MIXES WITH YELLOW LIGHT CREATING NEUTRAL WHITE LIGHT IN THE MIDDLE OF THE MODEL'S FACE. Credit: Alexander Izyumov/©Shutterstock.com.

yellow light is projected from one side, and a blue light on the other, you'll see each color on the sides of the face. However, when the two lights overlap in the middle, they create white light (because blue light and yellow light are complements), and no color cast will be apparent, revealing the true color of her skin.

Keep in mind these complements of light are only relevant when light is mixed with other light. If you are mixing red light with a green object, you can use the traditional color wheel and its complements to determine color mixtures. For example, red light mixed with cyan light results in white light, but red light on top of a cyan object results in a brownish-grey object.

This is important, because when a set or stage is lit, **colored gels** are used often to create a desired mood. There are also many types of lighting sources where the color temperature can be directly altered on a light by adjusting red, blue, and green diodes.

Three Characteristics of Colored Light
Colored light can be described in a similar way that we describe colored objects and pigments. As you will recall from Chapter 1, pigments can be categorized by hue, value, and intensity. Colored light is described by its dominant wavelength, luminosity, and purity. The **dominant wavelength** is similar to a hue. It describes the main wavelength present, and basically means the apparent color (e.g., blue). **Luminosity** refers to the brightness and relates to a color's value. **Purity** is similar to intensity or saturation, and describes the extent that the dominant wavelength is dominant.

Colored Gels
Light can be filtered through colored gels to manipulate the color of sets and the subjects. Gels are very heat resistant film sheets. Surprisingly, they were originally made with gelatin, but today, they're made from various plastics. Gels allow light

114

FIGURE 6-10

to shine through while appearing to tint the light a desired color.

Adding gels to lighting is considered **subtractive**, because it will subtract additional wavelengths and only allow the selected colors to pass through. The more intense the color, the more wavelengths the gel absorbs. Gels don't actually add color to your lighting; they remove the other wavelengths of color, which leaves you with the color you see.

The color of light also changes when the intensity is altered. Lights not only become darker when dimmed, but they also change temperature and become warmer. Therefore, filters and gels may be needed for consistent lighting and to balance the overall look of the set when multiple light sources are used. For example, some tungsten lights can appear too orange when used outside in natural daylight, so they need to be balanced with a blue gel.

Pay close attention to the colored gels that are added to the light, and try to go and see the lit sets in advance, if possible. For example, you may find yourself in a situation shooting a sci-fi scene, and the characters are wearing green face paint. If the room is lit completely **red**, that means all other colors have been

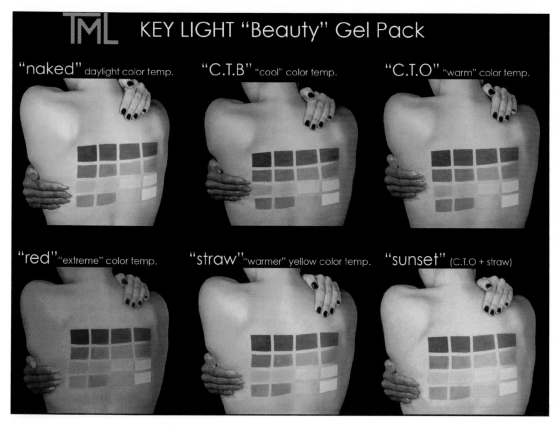

KEY LIGHT "Beauty" Gel Pack

"naked" daylight color temp.

"C.T.B" "cool" color temp.

"C.T.O" "warm" color temp.

"red" "extreme" color temp.

"straw" "warmer" yellow color temp.

"sunset" (C.T.O + straw)

Credit: Photo Courtesy of The Makeup Light.

removed from the light source, except for red. No green light will be left to reveal the green on their faces, which will cause their faces to appear grey.

The effects won't always be so extreme. For example, you may be shooting a night scene where **blue gels** are placed over the lights to set the tone. This only allows the blue wavelength of light to pass through. Warmer colors, like blush or red lipstick, will read as grey or even black.

If you have **deep yellow lighting** and a character with purple hair, the two complements will cancel each other out. This will result in brown or grey hair, depending on the tones of the yellow and the purple.

Remember that makeup is only flattering or enhanced by the quality of light it is seen under.
—Richard Corson (*Stage Makeup*)

Adding Warm Light

Red and Pink

Red lighting tends to make other reds and oranges appear more red. The face will also appear more red, so blushes and red lips will have less of an impact. Red and pink will make cool colors appear more grey, and add intensity to colors that are warm. Pink light will make yellow appear more orange. The make-up is affected less when pink light is used instead of red light, so the pink can typically be more flattering on a range of skin tones. However, red can be more flattering

on certain darker skin tones, because it can bring out warmth in the undertones.

Amber and Orange

Amber is flattering to most skin tones and can complement make-up choices. Amber adds warmth and life to skin and can neutralize cool shadows. Most skin tones will become more intensely yellow when using amber or orange. Reds and pinks will appear more orange. Warm undertones in dark skin can also be accentuated, which is typically preferred.

Yellow and Pale Yellow

Both yellow and pale yellow will slightly warm the skin and make-up. They will make cool colors (like purple) appear more grey. Yellow filters intensify other yellows, make blues more green, and reds more orange.

Adding Cool Light

Green

Green dulls and depletes the warmth of skin tones. Green light can also neutralize reds and oranges in lips and cheeks, depending on the intensity.

Blue-Green

Blue-green lowers the intensity of the skin color and can wash it out. Blue-green also darkens reds, so be careful with the amount of blush you add to the skin.

Blue

Blue also lowers the intensity of skin colors. Blue can make dark skin look even darker, and features can become less defined.

Violet and Purple

Violet and purple make reds and oranges appear more intense. Violet dulls greens. Violet light can be more flattering on darker skin tones than blue light (because it is slightly warmer).

LIGHTING FOR THEATER

"All actresses are artists in 'make-up'; they have to be. But the make-up for the stage and the make-up for the lights of the streets are very different."
—Billie Burke (1884–1970)

Colored lighting for theater is much more exaggerated than it is for film. It's used to portray the time of day, the mood, atmosphere, the season, and even define different characters. The lighting directly affects how we see sets and costumes. It's important to be aware of the light choices in advance, so your make-up looks its best.

One problem you may encounter in theater is that the lighting is always changing during the performance. You won't always have a chance to alter the make-up in the middle of a show. You may need to adjust the make-up design so that it

FIGURE 6-11 Fer Gregory/©Shutterstock.com

reads well during every shift of light and so that it's not harshly affected by the lighting.

It's important to work closely with other departments, too, because color design is an essential part of theater. Everyone's colors should coordinate and be balanced, so that nothing feels out of place. It's crucial to understand color harmonies and combinations for successful designs and color palettes. Set designers, costume designers, and hair and make-up artists typically decide on a palette in advance. Sometimes, they may even reference particular paintings or other art for color inspiration.

Light changes throughout the day. Mornings tend to feel more pink, and the afternoons seem more yellow and become even warmer as time passes with the setting sun. When evening approaches, the light becomes bluer. These changes are taken into consideration when the lighting is designed. Also considered are the seasons and temperatures. Cold is represented by cooler light, when the sun is lower. Summer and heat are represented by warmer light, when the sun is higher in the sky. Colored light can even be used to differentiate between characters.

Lighting for theater can change throughout a scene and occurs less with film and television. For example, a mid-scene light shift can occur when a character turns on a light switch, walks into a different room, or time has passed. Make sure your make-up design looks appropriate for all of these situations. If possible, try to look at the make-up during a full dress rehearsal from the house seating, so that you can see it the same way the audience will.

Imagine a character who is painted fully in red body paint and wearing a green costume. If green lights are projected on the person, their red-painted skin will appear dark grey or black, and their costume will appear green. If the light is changed to red, their skin will appear red, but their costume will appear black or grey. If the lighting is white, you will see both the red-painted skin and the green costume.

Ultraviolet Light

Ultraviolet or "black" light can be used in theater. Certain colors of paint and make-up only appear under black light. Knowing when and where to use these can be a helpful tool to reveal or conceal certain images on stage. Ultraviolet lighting also illuminates certain colors (especially neon colors) and gives them an illusion as if they are glowing. Dark colors can completely disappear under ultraviolet lighting, because they don't reflect anything back to the eye. You'll need to make sure that the colors that disappear, and the ones that glow, are intentional. It's essential to test your make-up under black lighting in advance, to avoid any surprises.

FIGURE 6-12 MAKE-UP ILLUMINATED UNDER UV LIGHTING. Andrey Arkusha/©Shutterstock.com.

LIGHTING FOR FILM AND TELEVISION

Lighting for film and television can be similar to lighting for theater, but it also has its differences.

A cinematographer can choose specifically what the viewer will see, while a theater audience will see the entire stage. Cameras do not capture the same information that our eyes do, and color can be translated much differently depending on the subject, environment, and the camera. Photographers and cinematographers both carefully pick and choose how and what they want us to see in the final product.

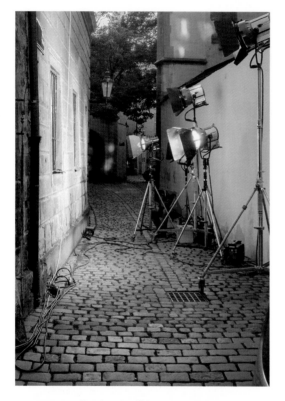

FIGURE 6-13 Gnatkovskiy/©Shutterstock.com.

Every time the camera moves, the lighting can be adjusted to suit the shot. This typically gives you time for minor make-up adjustments and touch-ups, as well. For example, you may notice a particular scene has yellow lighting and the blush you used earlier doesn't show up very well. Unlike in theater, these camera changes can give you the opportunity to add or subtract a little color if needed, in between scenes (that is, of course, as long as it doesn't affect the make-up **continuity**).

Luckily, most film, television shows, and commercials have monitors set up, so you can see how the make-up and the colors are reading through the camera as a scene is being shot. You may be surprised how different your application appears under a certain set's lighting. Sometimes camera tests are scheduled ahead of time in order to see how a specific make-up will look on-camera. This gives the make-up artist extra time for adjustments and even complex design changes.

However, keep in mind that the monitors on-set are not always calibrated to show accurate color, so you cannot always rely on them for your color choices. For example, certain monitors are used to make sure the camera is in focus so they have color and contrast settings specifically for the camera department. Also keep in mind that some monitors are not powerful enough to project what the camera is recording accurately.

Three-Point Lighting
Three-point lighting is one of the oldest lighting techniques used to professionally light a subject in film and television. The method consists of using a key light, a fill light, and a back light.

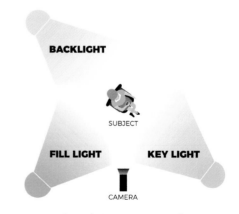

FIGURE 6-14 Graphic by Macrovector/©Shutterstock. com. Edited by author.

Key Light

A key light is the main light source, which gives off the most illumination.

Fill Light

A fill light is added to lighten shadows and reduce contrast. A fill light may not always be necessary. However, there can be multiple fill lights used at once.

Back Light

A back light is a light that shines from behind and separates the subject from the background. It can also be referred to as a rim light.

Cameras are only able to record the colors in front of them. If a certain wavelength of color is not hitting a subject, it won't show up on camera the way that we can perceive it in real life. This is because our brains understand and translate colors in ways that a camera can't. Also, certain lights aren't equipped to project every wavelength of color, so some of these colors may never appear on camera.

Color temperature and the use of gels are just as important in film and television as they are in theater, but they are typically used in a much more subtle way. You'll need to be aware of how these colors affect your make-up on the screen the same way you should for the stage. For example, blue gels may be used to simulate moonlight in film, but the blue will, most likely, be much less saturated than it would be for theater moonlight. Be aware there are also times where film lighting can be just as dramatic as theater lighting. Color may be intensified for a dramatic look like in a fantasy or sci-fi world, or even in a club or bar scene.

It is very common to use diffused, soft light when lighting someone's face for film. This helps flatter the face and soften shadows, while smoothing skin textures. However, sometimes the technique may be quite the opposite when intending to make somebody look worse (like if they're sick or even for lighting a creature). In this case, green and blue-green light could be used to help remove the redness or healthy flush from the face.

Your character may be put in many different atmospheres. They could be lit by streetlights, candlelight, artificial light, moonlight, and even neon light. You may not always get to see the character under these lighting situations ahead of time, but it's important to be aware of the shooting locations that day so that you can be well-prepared.

Problems with Color and Make-Up in Early Film

Selecting colors to flatter every skin tone can seem overwhelming today, but there was a different set of color problems caused by older technology in the past.

Early black and white movies were shot with **orthochromatic film**, which was very sensitive to blue light, and insensitive to red light. This meant blue skies, or even blue eyes, could appear white, and red would appear black. This became problematic with make-up, because adding red to the cheeks or lips would also translate as black. Consequently, make-up artists had to be cautious with the placement of these colors. For example, red blush on the cheeks would photograph as dark hollows, instead of a healthy flush. Traditional make-up had to be adjusted by using blues, greens, and yellows, while reserving colors like red to create darker shadows.

Eventually, a new black and white **panchromatic film** became popular in the late 1920s and it was sensitive to the entire visible color spectrum. This meant the different shades of grey were more accurate to the tonal values seen in life. Skin tones appeared more truthful and flattering, and reds no longer turned black. As a result, make-up also changed, so softer and more natural colors became an option. Make-

Green Replaces Red in Make-up for Television

GREEN lipstick and rouge replace the customary red in make-up designed for actresses appearing in television broadcasts. The television camera, it is explained, does not record the red coloring in the human complexion, leaving the transmitted image flat and unnatural. When green is substituted, however, the lips and cheeks of a performer appear in accurate relation of tones with other facial features as the image is projected on the screen of the receiver.

Betty Grable, film star, being made up for television

FIGURE 6-15 Article from *Popular Science Magazine*, January 1938.

up pioneer **Max Factor** was very important during this time, because he was constantly reformulating make-up to correspond with the advances in film technology. When colored film was finally invented, he had to redevelop his colors, once again, because the make-up used for black and white did not translate well into color.

Today, make-up is still changing, especially due to **high definition cameras,** which pick up much more detail than cameras did in the past. Older film cameras used to give a natural and flattering blur to facial features and colors. Make-up used to be much thicker and more powdery, but these film cameras were forgiving, so "cakey" make-up was perfectly acceptable. When high definition digital cameras were created, they were able to pick up new details (like pores) that were never seen before. This meant make-up could

no longer be thick and noticeable, but had to be reformulated to appear like natural skin. Many brands began to manufacture HD make-up lines in order to give a smoother and flawless coverage.

Dr. Jekyll and Mr. Hyde (1931)

In the 1931 film version of *Dr. Jekyll and Mr. Hyde*, director Rouben Mamoulian used a light shift to show the transformation of characters on camera. The cinematographer, Karl Struss, created a colored lighting effect that reacted with the make-up to create the shift from Dr. Jekyll to Mr. Hyde. This effect worked only because of the black and white film. This type of on-camera transformation had never been created before and Mamoulian kept it a secret for years before revealing the trick.

Mr. Hyde's monster-like character make-up was painted on in shadows with eye bags, wrinkles, and hollowed cheekbones. The trick was that the make-up artist, Wally Westmore, only used red make-up to paint the shadows. A light covered with a red gel was projected onto the make-up, which meant that the red make-up completely disappeared under the red lighting. A second light was covered with a green gel. While filming the scene, the red light was faded down and shifted naturally into the green light, which was turned up. It was essential to synchronize the two lights so that only the color changed and not the brightness. When the green light was projected onto the same make-up, it turned the red painted shadows black, revealing the Mr. Hyde monster make-up. The colored lighting change couldn't be detected due to the black and white film, so the result was the monster make-up magically appearing on the actor's face.

LIGHTING FOR PHOTOGRAPHY

Lighting for cinematography and photography share some of the same principals, but they can also be very different. It's important to be aware of your surroundings during a photo shoot, just like when applying make-up for a moving image. Sometimes, you'll be outside using only natural lighting, and sometimes you might be in a studio with dramatic lighting. There are countless lighting scenarios that can drastically affect your make-up design. Don't be afraid to ask a photographer to show you a sample shot, because what they're capturing can be completely different from what you see in real life.

Natural Light
Natural lighting for photography is exactly what it sounds like. The photographer makes use of the sunlight or moonlight as their light source on a subject. Direct sunlight can create high contrast, and it can also be diffused (like through the clouds) for a lower contrast effect. Sunlight can also bounce off objects, creating reflected light effects.

The weather and the time of day are big factors in how the natural lighting will appear on camera.

Magic hour, also known as **golden hour**, is a term that is used both in photography and cinematography. It describes the hour that occurs just after a sunrise or just before a sunset, when the lighting creates a warm glow and casts flattering shadows, highlights, and colors.

Sometimes, when shooting in natural light, adding a boost of light from another direction can help make the shot more appealing. A **board reflector** (also known as a **bounce board**) can be used to reflect and redirect sunlight onto the subject. Commonly, a white reflective board is used to reflect a neutral shadow. It's an effective tool when shooting portraits, because it can provide lighting to a part of the face where the sun isn't hitting. Board reflectors can also be helpful in studio lighting in order to reflect the light emitted from bulbs. Silver and gold board reflectors are also popular for reflecting a more dramatic cool light (silver reflector) or warm light (gold reflector).

Artificial Light
Artificial light can be used when a photographer wishes to control light, or use a different source from natural light. Incandescent, fluorescent, or LED lights can be used for a range of cool-to-warm temperatures, depending on the look of the shot. The lights can either be used in a controlled environment (like in a studio) or added to naturally-lit situations.

Strobe lights (also known as **flash** lighting) create a quick burst of light, instead of providing continuous lighting like film lights do. Most professional studio strobe lights are separate lights that can be placed in the desired direction, and can be adjusted to suit the photo. Typically, the strobe lights are diffused with **umbrellas** or **softboxes** (both are lighting devices are used to soften the light source) to make the lighting less harsh. A flash found on a simple camera uses the

same concept, but the results are typically less visually appealing, because they are fixed on the camera and don't allow for adjustments. Flash bulbs are balanced to daylight (unless they have added colored gels), so when applying make-up for a photo-shoot using flash photography, make sure it is in a daylight balanced room.

FIGURE 6-16 Africa Studio/©Shutterstock.com.

A common lighting method used in portraits (e.g., headshots or fashion) is to place a bright light directly behind the lens of the camera to brighten the face. This can wash out subtle make-up (like blush), so it's helpful to ask the photographer to see the shot before proceeding so you can adjust the make-up accordingly. Also, be aware of any colors surrounding your subject, because they may reflect onto the skin.

Problems with Make-Up and Flash Photography

HD powder was created to eliminate the grainy particles that could be present with the original talc-based powder formulas found in make-up. HD powders are made from **silica** or **mica**, instead of talc, and have a smooth texture and finish as make-up. These powders work effectively when filming with high definition cameras (where the name came from) because newer digital cameras pick up textures that film cameras did not.

The problem with using HD powder is when flash photography is used. When the flash of the bulb

hits the silica or mica, it can reflect back to the camera. This means if you've applied silica powder on the face for a photo with a flash, the person wearing it can appear to have white residue wherever it is present. Therefore, be sure to check your labels before applying any make-up where you know there will be flash photography and only use **talc**- or **rice**-based powders. Only use HD powders for video work, or when there is no flash or strobe present. Also, be sure to carefully blend any make-up because bright strobe lighting may pick up details that we can't see with the naked eye.

COLOR GRADING

One thing to keep in mind when working with film, television, and photography is that the color in the final image will most likely change from the image you saw on the day that it was shot. **Color grading** (also known as **color timing** or **color correcting**) is the process of digitally altering and correcting the final colors to achieve the desired look. It is essential in film and television for a colorist to color grade each scene. Scenes can be colored for a cohesive look, or they can be made to contrast each other to help differentiate between atmospheres, time of the day, or even flashback scenes. Colors can be made warmer, cooler, muted, vibrant, lighter, or darker. The hue, value, and intensity of colors can make a big impact on how a viewer feels about an image.

As a make-up artist, you won't typically need to be concerned with color grading, because you won't necessarily be a part of the process. However, it is something you should be aware of. You may have purchased the exact color and brand of lipstick that was used in a movie to replicate a look, but discovered that it looks completely different in person. This is most likely due to the lighting of a scene as well as the final color grade.

Look at the two photographs of Italy. They are created from the identical image, but colored differently. The main dissimilarity is that one is

warmer, and the other is cooler. The warmer image appears as if the sun is just setting on a welcoming summer evening. The cooler photograph seems earlier in the day, and the overall feeling is colder. The water looks much more inviting in the warmer photo. These feelings are completely psychological, because both images are created from the same photograph. It's important that a colorist, photographer, and a cinematographer take these associations into consideration when deciding the overall mood and color of a shot.

In the second image, the woman wearing red lipstick has been color graded in six different ways. You can see how this not only affects the color of her complexion, but also her red lips, scarf, and the background. The tone of her hair even varies from cool, warm, and neutral, depending on how the photograph has been colored.

123

FIGURE 6-17

FIGURE 6-18

FIGURE 6-19 Original Image by Kosim Shukurov/©Shutterstock.com. Edited by author.

I hope that this book has given you an understanding of why we see color and the many ways we can manipulate it as make-up artists. However, it's difficult to fully comprehend color theory simply by reading about it. I encourage you to practice on your own with make-up and with paint, and experiment mixing different colored pigments. Try to create your own colors, rather than selecting pre-made shades. The more you work with color, the easier it will become, and the more natural it will feel.

The make-up world is always changing, but the importance of possessing a foundation skill of understanding color will never change. Keep practicing. You will never finish learning, and you will never run out of things to create.

1) Academy of Freelance Makeup. *Makeup is Art: Professional Techniques for Creating Original Looks.* Carlton Books Limited. 2013. Print.

2) Albers, Joseph. *Interaction of Color: 50th Anniversary Edition.* Yale University Press. 2013. Print.

3) Aucoin, Kevyn. *Face Forward.* Little, Brown and Company. 2000. Print.

4) Aucoin, Kevyn. *Making Faces.* Little, Brown and Company. 1997. Print.

5) Ball, Philip. *Bright Earth: Art and the Invention of Color.* University of Chicago Press. 2003. Print.

6) Brown, Bobbi. *Bobbi Brown Makeup Manual: For Everyone from Beginner to Pro.* Grand Central Life & Style. 2011. Print.

7) Brusatin, Manlio. *History of Colors.* Shambhala. 1991. Print.

8) Campbell, Drew. *Technical Theater for Nontechnical People, 2nd Edition.* Allworth Press. 2004. Print.

9) Chevreul, M.E. *Principles of the Harmony and Contrast of Colours: And Their Applications to the Arts.* Schiffer Publishing. 1997. Print.

10) Corson, Richard. *Fashions in Makeup, from Ancient to Modern Times, Revised Edition.* Peter Owen Publishers. 2005. Print.

11) Corson, Richard. Glavan, James. Norcross, Beverly Gore. *Stage Makeup, 10th Edition.* Focal Press. 2016. Print.

12) Da Vinci, Leonardo. *A Treatise on Painting.* Dover Publications. 2005. Print.

13) Downing, Sarah Jane. *Beauty and Cosmetics 1550–1950.* Shire Publications. 2012. Print.

14) Eckstut, Joann, and Eckstut, Arielle. *The Secret Language of Color.* Black Dog & Leventhal. 2013. Print.

15) Edwards, Betty. *Color: A Course in Mastering the Art of Mixing Colors.* TarcherPerigee. 2004. Print.

16) Eldridge, Lisa. *Face Paint: The Story of Makeup.* Harry N. Abrams. 2015. Print.

17) Fine, Sam. *Fine Beauty: Beauty Basics and Beyond for African American Women.* Riverhead Hardcover. 1998. Print.

18) Finlay, Victoria. *The Brilliant History of Color in Art.* J. Paul Getty Museum. 2014. Print.

19) Gage, John. *Color and Culture: Practice and Meaning from Antiquity to Abstraction.* University of California Press. 1999. Print.

20) Gerritsen, Frans. *Evolution in Color.* Schiffer Publishing. 1997. Print.

21) Guineau, Bernard. *Colors: The Story of Dyes and Pigments.* Harry N. Abrams. 2000. Print.

22) Gurney, James. *Color and Light: A Guide for the Realist Painter.* Andrews McMeel Publishing. 2010. Print.

23) Hornung, David. *Color, 2nd Edition: A Workshop for Artists and Designers.* Laurence King Publishing. 2012. Print.

24) Iman. *The Beauty of Color.* Putnam Adult. 2005. Print.

25) Itten, Johannes. *The Elements of Color: A Treatise on the Color System of Johannes Itten Based on His Book the Art of Color.* Van Nostrand Reinhold Company. 1970. Print.

26) Kandinsky, Wassily. *Concerning the Spiritual in Art.* Dover Publications. 1977. Print.

27) Kerker, Milton. *The Scattering of Light and Other Electromagnetic Radiation: Physical Chemistry: A Series of Monographs.* Academic Press. 2016. Print.

28) Landau, David. *Lighting for Cinematography: A Practical Guide to the Art and Craft of Lighting for the Moving Image (The CineTech Guides to the Film Crafts).* Bloomsbury Academic. 2014. Print.

29) McLean, Adrienne L. *Costume, Makeup, and Hair (Behind the Silver Screen Series).* Rutgers University Press. 2016. Print.

30) Mollica, Patti. *Color Theory: An Essential Guide to Color—From Basic Principles to Practical Applications.* Walter Foster Publishing. 2013. Print.

31) Munsell, A. H. *A Color Notation: An Illustrated System Defining All Colors and Their Relations by Measured Scales of Hue, Value, and Chroma (Classic Reprint).* Forgotten Books. 2017. Print.

32) Poucher, W.A. *Poucher's Perfumes, Cosmetics and Soaps: Volume 3: Cosmetics. 9th Edition.* Springer. 1993. Print

33) Powell, William F. *Color and How to Use It.* Walter Foster Publishing. 1984. Print.

34) Powell, William F. *Color Mixing Recipes for Portraits: More than 500 Color Combinations for Skin, Eyes, Lips, and Hair: Featuring Oil and Acrylic—Plus a Special Section for Watercolor.* Walter Foster Publishing. 2006. Print.

35) Quiller, Stephen. *Color Choices: Making Color Sense out of Color Theory.* Watson-Guptill. 2002. Print.

36) Rossotti, Hazel. *Colour: Why the World Isn't Grey.* Princeton University Press. 1985. Print.

37) Sidaway, Ian. *Color Mixing Bible.* Watson-Guptill. 2002. Print.

38) Sidelinger, Stephen J. *Color Manual.* Prentice Hall. 1985. Print.

39) Stern, Arthur. *How to See Color and Paint It.* Churchill & Dunn, Ltd. 2015. Print.

40) Timpone, Anthony. *Men, Makeup, and Monsters: Hollywood's Masters of Illusion and FX.* St. Martin's Griffin. 1996. Print.

41) Walther, Ingo F. *Impressionist Art: 1860–1920.* Taschen. 2016. Print.

Achromatic—(adj.) without color. Neutral.

Additive color—(n.) color mixing using colored light. Certain wavelengths are added to what we see.

After-image—(n.) an optical illusion where our eyes create an apparition of a color's complement.

Analogous colors—(n.) groups of harmonious colors that are next to each other on the color wheel.

Artery—(n.) a blood vessel that carries blood away from the heart and contains brighter, more oxygenated blood.

Back light—(n.) a light that shines behind a subject to separate it from the background when lighting a subject in television or film. Also known as a rim light.

Bald cap—(n.) a rubber or vinyl cap used to hide the hair and imitate baldness.

Bilirubin—(n.) a yellow pigment found naturally in mucus and skin.

Biliverdin—(n.) a bile pigment.

Binder—(n.) a substance that is mixed with a pigment, which causes it to adhere to a surface. Binders are used to create paint and make-up.

Board reflector—(n) a reflective board used to reflect and redirect sunlight onto a subject. Also known as a bounce board.

Bounce board—(n) a reflective board used to reflect and redirect sunlight onto a subject. Also known as a board reflector.

Bronzer—(n.) make-up used to warm the complexion and mimic tanned skin.

Capillary—(n.) the blood vessels that distribute oxygen to different tissues, which are responsible for the redness in our lips and cheeks.

CFL (Compact Florescent Light) —(n.) energy saving light bulbs that are available in different color temperatures.

Chroma—(n.) the strength or weakness of a hue. Also referred to as intensity, saturation, or purity.

CMY Color System—(n.) Cyan-Magenta-Yellow System. The primary system for mixing colors for printing where the primary colors are cyan, magenta, and yellow.

Color constancy—(n.) a phenomenon where our brain perceives and categorizes a color based on preconceptions.

Color correction—(n.) a technique that uses complementary colors to neutralize unwanted colors.

Color grading—(v.) the process of digitally altering the final colors of an image in cinematography and photography.

Color temperature—(n.) color classifications based off their psychological effects. Warm colors are reminiscent of fire and warmth, and cool colors are reminiscent of ice and coldness.

Color theory—(n.) the study of color principles that allow us to define and practically understand color.

Color wheel—(n.) a diagram where colors are arranged in a circle in order of the visible spectrum.

Complementary colors—(n.) opposite colors that are directly across from each other on the color wheel.

Complementary grey—(n.) a grey that has no color cast and is completely neutral. Also known as a neutral grey.

Concealer—(n.) a pigmented make-up that is used to cover unwanted colors of the skin (e.g., blemishes or under-eye discoloration). Concealers are typically thicker and more pigmented than foundations.

Continuity—(n.) when unity is maintained throughout scenes in order to avoid errors when a movie or television show is edited continuously.

Contour—(v.) to add highlights or shadows to accentuate or hide features.

Contusion—(n.) a bruise.

Cool color—(n.) colors reminiscent of coldness and ice. Typically blue, green, and purple.

Cool undertone—(n.) the appearance of bluish-pink, rosy, or blue-purple in skin tones.

Daylight bulbs—(n.) light bulbs that are intended to mimic the color temperature of daylight.

Dermis—(n.) the second layer of the skin.

Dominant wavelength—(n.) the apparent color that describes the main wavelength of light that is present.

Double complementary colors—(n.) also known as tetradic colors. A color scheme where four colors form a rectangle on the color wheel.

Dye—(n.) colored particles used to create stains or other colorants including make-up. Unlike pigments, dyes are soluble.

Epidermis—(n.) the top layer of the skin.

Fill light—(n.) a light that is added to lighten shadows and reduce contrast when lighting a subject in television or film.

Flash—(n.) a light used in photography that creates a quick burst of light. Also known as strobe lighting.

Flocking—(n.) tiny colored fibers that can be suspended to color materials intrinsically.

Foundation—(n.) make-up that is used to even out the natural skin variations on the face.

Frostbite—(n.) when skin tissue freezes and the blood flow is reduced to the affected area.

Full spectrum—(n.) when all three primary colors of light are mixed and the result is white.

Gels—(n.) thin colored plastic sheets added to a light, which subtract colored wavelengths and only allow selected colors to pass through. They appear to tint a light a desired color.

Golden hour—(n.) a term used in photography and cinematography which describes the hour that occurs just after a sunrise or just before a sunset, when the lighting creates a warm glow and casts flattering shadows, highlights, and colors. Also known as magic hour.

Grey scale—(n.) a numbered scale that shows a range in value. Also known as a value scale.

HD powder—(n.) powder developed to smooth the skin textures which are noticeable when using high definition cameras. Usually made from silica or mica.

Hemoglobin—(n.) protein in the blood that transports oxygen.

High definition—(adj.) describes digital cameras that pick up extreme detail, which makes make-up applications less forgiving.

Highlight—(v.) to add a brighter color to an area to create the illusion that it is coming forward.

Hue—(n.) a color labeled by its familiar name.

Hyperpigmentation—(n.) darkening of the skin due to excess melanin.

Illuminator—(n.) particles that can be added to make-up which reflect light and result in a glittery or shimmery effect.

Impressionism—(n.) a 19th century artistic movement where artists painted with small patterns and brush strokes instead of blending.

Incandescent—(adj.) describes light that is created by heating up a piece of filament at a high temperature.

Inorganic pigment—(n.) also known as a mineral pigment. They contain salts and metallic oxides and were traditionally derived from the earth, but can also be made synthetically.

Insoluble—(adj.) particles that cannot be dissolved by a liquid.

Intensity—(n.) the strength or weakness of a hue. Also referred to as chroma, saturation, or purity.

Intrinsic—(adj.) belonging to or lying within a given part. When a material is colored intrinsically, the color is trapped inside the object.

Kelvin—(n.) a unit used to measure color temperature of light, and represented by a "K".

Key light—(n.) the main source of light when lighting a subject in television or film.

Lake—(n.) a type of organic pigment created by bonding a soluble dye with an aluminum substrate that makes it an insoluble pigment.

LED (Light Emitting Diode) —(n.) energy-saving light bulbs that are available in different color temperatures.

Luminosity—(n.) the brightness of a color. The term luminosity is used when describing the brightness of light.

Magic hour—(n.) a term used in photography and cinematography which describes the hour that occurs just after a sunrise or just before a sunset, when the lighting creates a warm glow and casts flattering shadows, highlights, and colors. Also known as golden hour.

Melanin—(n.) the pigment in our skin, eyes, and hair that is responsible for our color variations and protects us from ultraviolet radiation.

Melanocytes—(n.) the melanin-producing cells that are responsible for the change in our skin's pigmentation.

Mineral pigment—(n.) also known as an inorganic pigment. These contain salts and metallic oxides and were traditionally derived from the earth, but can also be made synthetically.

Modern pigment—(n.) also known as an organic pigment. These are made from plants and animals, but can also be made synthetically.

Monochromatic—(adj.) involving only one color in different tints, shades, and tones.

Mordant—(n.) a binder, typically a metal ion, used for turning dyes into pigments.

Neo-Impressionism—(n.) —A 19th century Impressionistic painting technique that included Pointillism and was led by painter Georges Seurat.

Neutral grey—(n.) a grey that has no color cast and is completely neutral. Also known as a complementary grey.

Neutral undertone—(n.) a skin tone with no obvious color temperature.

Olive undertone—(n.) an undertone that may have a slight olive green cast. Olive tones are often neutral, but sometimes are considered to be warm toned.

Opaque—(adj.) describes when no light travels through an object, so you are unable to see through it.

Optical color mixture—(n.) an optical illusion where our eyes blend alternating patterns of color.

Optical illusion—(n.) when our eyes deceive us and perceive something that is different from reality.

Organic pigment—(n.) also known as a modern pigment. These are made from plants and animals, but can also be made synthetically.

Orthochromatic film—(n.) early black and white film that was very sensitive to blue light and insensitive to red light.

Panchromatic film—(n.) early black and white film from the 1920s that replaced orthochromatic film because it was sensitive to the entire visible color spectrum.

Peak chroma value—(n.) a color's highest intensity and the value associated with it. Each color is most intense at a different value.

Pigment—(n.) the colored particles used to create paints and other colorants including make-up. Unlike dyes, pigments are insoluble.

Pigmentation—(n.) pigmentation in a product refers to the percentage of pigment present in the formula.

Pointillism—(n.) a type of Neo-Impressionism inspired by color theory using tiny painted dots of color that created an optical mixture.

Primary colors—(n.) colors that cannot be created by intermixing any other colors.

Primary colors of light—(n.) the primary colors of light are red light, green light, and blue light.

Primary triad—(n.) the triangle on the color wheel that the three primary colors form.

Prosthetic—(n.) an element glued to the skin in order to create different features in make-up applications.

Purity—(n.) when describing light, purity refers to its intensity or saturation and the extent that a wavelength is dominant.

Retinal fatigue—(n.) when the color sensors of the eye are overexposed causing an optical illusion.

RGB Color System—(n.) Red-Green-Blue System. The primary system for mixing colored light where the primary colors are red, green, and blue.

Rim light—(n.) a light that shines behind a subject to separate it from the background when lighting a subject in television or film. Also known as a back light.

RYB Color System—(n.) Red-Yellow-Blue System. The primary system for mixing colored pigments where the primary colors are red, yellow, and blue.

Saturation—(n.) the strength or weakness of a hue. Also referred to as intensity, chroma, or purity.

Secondary color—(n.) the mixture of two primary colors.

Shade—(n.) a color that has been mixed with black.

Shading—(v.) to add a darker color to an area to create the illusion that it is set backward.

Simultaneous contrast—(n.) an optical illusion which causes colors to appear different when they are surrounded by another color.

Soft box—(n.) a lighting device used to soften a light source.

Soluble—(n.) a particle that will dissolve when combined with a liquid like water or oil.

Spectral color wheel—(n.) the color wheel according to how it relates to light and colored vision.

Split-complementary colors—(n.) a three-hue variation of a complementary color scheme where one of the two complements is split using its surrounding colors.

Square color scheme—(n.) four colors creating a square on the color wheel.

Stipple—(v.) to lightly press or stamp color with a sponge or brush, creating texture.

Strobe—(n.) a light used in photography that creates a quick burst of light. Also known as flash lighting.

Subtractive color—(n.) the process of mixing colored pigments and dyes. Certain wavelengths are subtracted from what we see.

Tertiary color—(n.) the result of mixing a secondary color with a primary color.

Tetradic colors—(n.) 4 colors that form a rectangle on the color wheel and consist of two pairs of complements. Also known as double complementary colors.

Three-point lighting—(n.) using a key light, a fill light, and a back light to professionally light a subject in film and television.

Tint—(n.) a color that has been mixed with white.

Tone—(n.) a color that has been mixed with grey.

Toner—(n.) a type of organic pigment made with a safe metal that is not aluminum.

Translucent—(adj.) describes when some light passes through an object, so that you can partially see though it.

Transparent—(adj.) describes when light passes through an object, so that you are able to see what is behind it.

Triad—(n.) a triangle on the color wheel.

Triadic colors—(n.) three colors spaced evenly on the color wheel forming a triangle.

True pigment—(n.) a rare type of organic pigment that does not contain any metal ions and is naturally insoluble.

Ultraviolet light—(n.) lighting which illuminates certain colors (especially neon colors) and gives them the appearance as if they are glowing.

Umbrella—(n.) a lighting device used to soften a light source.

Undertone—(n.) the predominant color of a person's skin, or the skin's hue. Undertones are categorized as cool, neutral, and warm.

Value—(n.) a measurement that describes how light or dark a color is. It can also be referred to as brightness or luminosity.

Value scale—(n.) a numbered scale that shows a range in value. Also known as a grey scale.

Vein—(n.) a blood vessel that carries blood toward the heart and contains darker, less oxygenated blood.

Visible spectrum—(n.) the wavelengths from the electromagnetic spectrum that are visible to the human eye. The observable colored light waves.

Warm color—(n.) colors reminiscent of fire and warmth. Typically red, orange, and yellow.

Warm undertone—(n.) the appearance of yellow, peach, gold, or warm rust in skin tones.

White balance—(v.) to adjust the color temperature in a camera to remove color casts and create a neutral white.

135

square color scheme 11, 85
subtractive color 23, 112, 114

T

tanning 50, 83–84
tattoos : covering 72–74; creating 98–99
teeth 99
tertiary colors 8, 12, 16
tetradic colors 11, 85
theater 75–76, 111, 116–118
thinning out products 70, 97
three-point lighting 118
tint 18, 41–42, 68
tinted moisturizer 69
tone 18
toner 39
translucency: pigments 22, 34, 39–42, 45;
 cosmetics: 69–71, 81, 83; special effects 98,
 101–102
transparency 39, 40, 70, 84, 99
triadic colors 10, 85
true pigment 39

U

ultraviolet light 4, 117
umbrella 121
under-eye 50, 71–73, 76
undertone 7, 64–68, 71, 76–79, 81–84, 90, 115–116

V

value 12–13, 15–18, 24–26, 50, 53, 64, 66–68, 73, 76, 82, 84,
 114, 119, 122
value scale 12–13, 16, 18, 66
Van Gogh, Vincent 19
veins 50, 64–65, 90, 99, 102
visible spectrum 4–5

W

warm colors 6–7, 14, 41, 42, 64–79, 82–84, 103
warm light 108–110, 114–116, 121–123
waterline 79
white balance 109

Y

YInMn Blue 34, 36